BASEBALL
IN READING

To Devin + Sean —
Best Wishes

Reading was a stepping stone to the big leagues for me. It was a very good, competitive league. I learned a lot playing here. The people of Reading treated us unbelievably. We had great fan support.

—Larry Bowa, manager of the Philadelphia Phillies

BASEBALL IN READING

Charles J. Adams III

ARCADIA
PUBLISHING

Published by Arcadia Publishing
Charleston SC, Chicago IL, Portsmouth NH, San Francisco CA

Printed in the United States of America

Library of Congress Catalog Card Number: 2003102255

For all general information contact Arcadia Publishing at:
Telephone 843-853-2070
Fax 843-853-0044
E-mail sales@arcadiapublishing.com
For customer service and orders:
Toll-Free 1-888-313-2665

Visit us on the Internet at www.arcadiapublishing.com

CONTENTS

ACKNOWLEDGMENTS

This book would not have been possible without the cooperation of many individuals and organizations.

The heaviest historical hitter has to be Harold Yoder, executive director of the Historical Society of Berks County (HSBC). When he was notified that a volume of photographs and factoids related to baseball was in the works, his curatorial eyes lit up like a rookie called in to make his first start. It is no secret to anyone who knows the historical society director that he is equally adept with the vital stats of Daniel Boone and Bob Boone, Conrad Weiser and Connie Mack, and Henry Muhlenberg and Hank Greenberg. Come springtime, Yoder is as much a fixture at FirstEnergy Stadium as the funnel cake, dollar hot dogs, and Frenchy Bauman. Digging deeply into the dusty bins and files of the society's museum, library, and storage rooms, Yoder emerged with a treasure chest of diamond gems. It is reasonable to state that every photograph in the HSBC was ferreted out by Yoder. Some were tattered and torn, some were graying and fading, and some seemed beyond the reach of even the most sophisticated copying technology. What does appear in these pages is a tribute to that technology.

Another heartfelt thank-you goes to the folks at the Reading Phillies organization. General manager Chuck Domino, assistant general manager Scott Hunsicker, Matt Jackson, Tonya Adams, and Ashley Forlini—all in the Phillies' front office—readily opened their files and offered their help. It was especially Rob Hackash and Andy Kauffman, in their office in the press box—the "Broadway Charlie" Wagner Press Box—who helped me sort through their drawers and cabinets filled with random and sundry baseball bounty.

Then there are Charles M. Gallagher, managing editor, and Terry Bickhart, sports editor, of the *Reading Eagle*. Both gave the green light to the newspaper's photograph files and allowed me to use whatever I found. My discoveries, quality pictures from the talented staff, are evident in these pages.

Two professional photographers were also key players in the ultimate publication of this book. David M. Schofield, of Belmar, New Jersey, and Ralph L. Trout, of Shillington, Pennsylvania, both provided great help and incredible pictures.

Other folks who are to be thanked for lending their time, expertise, encouragement, and sometimes rare, valuable, and delicate photographs and mementos include Dr. Richard P. Flannery, president of the Berks County Chapter of the Pennsylvania Sports Hall of Fame and executive director of the Berks County Interscholastic Athletic Association; Rich DeGroote, executive director of the Olivet Boys and Girls Clubs; Paul Miller, Sinking Spring Historical Society; Kevin Devera; Mitch Gerhart, WEEU sports director; Francis "Ducky" Turner; Jim Pollock; Harry "Cy" Young; Tony Zonca; Joe Harring; Charlie Wagner; Cooter Jones; Dick Gernert; Ron Romanski, Bill Uhrich, Dennis R. Bender, Chad A. DeShazo, and Janet Kelly, *Reading Eagle* photographers; George Arentz, *Reading Eagle* artist; the Philadelphia Phillies; Melissa Bruno; Loretta Holland, in the office of the International League; and Steve Densa, in the office of Minor League Baseball.

INTRODUCTION

Mention Reading, Pennsylvania, to a baseball old-timer, and names such as Furillo, Kurowski, Colavito, Maris, and Petrocelli will come to their minds. To a fan with a little gray around their temples, the city's name conjures memories of the likes of Bowa, Schmidt, and Luzinski. Younger baseball followers associate Reading with guys like Rolen, Burrell, Wolf, and Byrd. Some of these ballplayers came *from* Reading. Others came *to* Reading. Some came to play and some came to stay. Each left indelible memories, and in their own ways, these and many others made their marks on the history of the city that became Baseballtown.

Many—too many—names have faded from those memories and that history. Little is left to pay proper tribute to their contributions to not only the city of Reading but the very heritage of baseball. The people of Reading take baseball very seriously. They have been doing so since just after the Civil War. As town teams rambled from field to field across Berks County, more organized and better-funded teams were formed in the county seat of Reading.

When high-level minor leagues came to be, they came to Reading. The city was positioned to play at the very highest level, the International League. When fan, financial, and facility support waned, Reading continued to support teams in lesser leagues.

After a decade without minor-league ball in the city, a band of civic visionaries decided to do something about it. The dawn of the "modern era" of baseball in Baseballtown was heralded as the lights of Municipal Memorial Stadium were switched on and the Indians came to call. This is not to say those lean years that preceded the return of minor-league ball were uneventful for the Reading baseball legacy. Although there was no stadium and no team for future big-leaguers to make their marks in Reading from 1942 to 1951, several stars emerged from Reading and left their names in the record books.

The pictures in this book and the captions that accompany them represent the first such collection in the history of Reading and Berks County. It is the first, but likely not the last. I am but the starter in what could be and should be a continuing compilation of the images of Reading baseball. With the publication of this book, I hand the ball over to the bullpen and retreat to the clubhouse knowing I have done all I could. I hold my head high with the hopes that my start in this game of history will prompt those who relieve me to seek and find more photographs, documents, and artifacts related to local ballparks and ballplayers. The Historical Society of Berks County will certainly serve as a repository for the same.

What really matters is that the pictures in this book may jog some memories. Perhaps one of the faces on one of the team pictures is a long-lost relative, neighbor, friend, or hero. What matters even more is that the proceeds from the publication of this book go to the Historical Society of Berks County and Baseballtown Charities.

—Charles J. Adams III
Spring 2003

Records of Minor-League Teams in Reading
1919–2002

Year	Team	League	Wins	Losses	Finish	Year	Team	League	Wins	Losses	Finish
1919	Coal Barons	Intl.	51	93	8	1969	Phillies	Eastern	81	59	2
1920	Marines	Intl.	65	85	5	1970	Phillies	Eastern	78	63	2
1921	Aces	Intl.	56	110	8	1971	Phillies	Eastern	72	67	2
1922	Aces	Intl.	71	93	6	1972	Phillies	Eastern	70	69	5
1923	Keystones	Intl.	85	79	3	1973	Phillies	Eastern	76	62	2#
1924	Keystones	Intl.	63	98	7	1974	Phillies	Eastern	69	66	4
1925	Keystones	Intl.	78	90	5	1975	Phillies	Eastern	84	53	1
1926	Keystones	Intl.	31	129•	8	1976	Phillies	Eastern	54	82	7
1927	Keystones	Intl.	43	123	8	1977	Phillies	Eastern	63	57	7
1928	Keystones	Intl.	84	83	4	1978	Phillies	Eastern	79	57	2
1929	Keystones	Intl.	80	86	7	1979	Phillies	Eastern	77	61	2
1930	Keystones	Intl.	63	98	7	1980	Phillies	Eastern	78	61	2T
1931	Keystones	Intl.	79	88	6	1981	Phillies	Eastern	76	63	3
1932	Keystones	Intl.	50	66	7*	1982	Phillies	Eastern	63	75	5
1933	Red Sox	NY-Penn	80	56	2	1983	Phillies	Eastern	96	44	1
1934	Red Sox	NY-Penn	72	66	3	1984	Phillies	Eastern	56	83	8
1935	Red Sox	NY-Penn	23	50	7+	1985	Phillies	Eastern	58	79	8
1940	Chicks	Inter-State	76	52	1	1986	Phillies	Eastern	77	59	1
1941	Brooks	Inter-State	74	51	3	1987	Phillies	Eastern	76	63	3
1952	Indians	Eastern	75	63	3	1988	Phillies	Eastern	67	69	5
1953	Indians	Eastern	101	47	1	1989	Phillies	Eastern	68	71	4
1954	Indians	Eastern	71	69	4	1990	Phillies	Eastern	55	82	8
1955	Indians	Eastern	84	53	1	1991	Phillies	Eastern	72	68	5
1956	Indians	Eastern	80	59	3	1992	Phillies	Eastern	61	77	6
1957	Indians	Eastern	74	66	3#	1993	Phillies	Eastern	62	78	7
1958	Indians	Eastern	75	58	2	1994	Phillies	Eastern	58	82	9
1959	Indians	Eastern	71	69	5	1995	Phillies	Eastern	73	69	3T#
1960	Indians	Eastern	69	71	4	1996	Phillies	Eastern	66	75	7T
1961	Indians	Eastern	59	81	6	1997	Phillies	Eastern	74	68	4
1963	Red Sox	Eastern	61	79	6	1998	Phillies	Eastern	56	85	10
1964	Red Sox	Eastern	80	60	2	1999	Phillies	Eastern	73	69	3
1965	Indians	Eastern	53	86	6	2000	Phillies	Eastern	85	57	1
1967	Phillies	Eastern	70	69	6	2001	Phillies	Eastern	77	65	4T
1968	Phillies	Eastern	81	59	2#	2002	Phillies	Eastern	76	66	3

• All-time International League record for most losses in a season.

* Standing of Reading club when transferred to Albany.

+ Standing of Reading club when transferred to Allentown.

T Tie.

Postseason league champion.

One

THE SIX ERAS OF BASEBALL IN READING

The history of minor-league baseball in Reading can be divided into six eras. In the very early years, from the 1890s through 1918, the city fielded teams in low-level leagues such as the Atlantic, Pennsylvania State, Tri-State, Union, and New York State Leagues.

The second era was arguably the glory days of the game in town. It was a time when Reading was at the highest level of the minors, the Class AA International League, from 1919 to 1932. During those 14 years in the International League, Reading never finished higher than third place (1923). In 1926, the Reading Keystones sank to a record of 31 wins and 129 losses. It was then—and remains to this day—the worst record (lowest winning percentage, .194; most losses, 129) in International League history. In 1927, the Keystones won 43 games and lost 123. That loss total is the second highest in International League history.

Baseball fans were treated to barnstorming big-leaguers (Babe Ruth took a few turns at bat at the old Lauer's Park) and budding future stars. In 1922, the Reading "Keys," as the Keystones were known, were managed by a future member of the Baseball Hall of Fame, Charles Albert Bender. A member of the Chippewa tribe and graduate of the Carlisle Indian School, Bender is credited with inventing the nickel curve, or slider.

Despite all that, fan and financial support eroded and the International League franchise was moved from Reading to Albany, New York, before the end of the 1932 season. Baseball in Reading entered a fallow period of play in the Class A New York–Pennsylvania League in 1933, 1934, and part of the 1935 season. The Boston Red Sox were the parent club in 1933 and 1934, and the Brooklyn Dodgers supported the franchise in 1935. Again, dismal attendance figures doomed the team, and the Dodgers pulled the plug in midseason and moved the franchise to Allentown. From 1936 through 1939, there was no minor-league play in Reading. It was the first of two "dark ages" of baseball in town.

In 1940, the Reading Chicks opened play in the Class B Inter-State League. Under manager Tom Oliver, the Chicks won the pennant but were losers at the gate. The following year, Brooklyn gave Reading another chance, but disappointing attendance figures (977 average per game) again sent the Dodgers looking for another city.

By 1942, Reading baseball was in what could be considered its darkest age. It was a sad period between the 1941 departure of the Brooklyn-affiliated Reading Brooks and the "modern era" that began when Municipal Memorial Stadium was opened and the Indians came to town. It was a decade not only without a minor-league team but also without a stadium. Ten years before the first crack of the bat echoed in the night at the new stadium in 1952, baseball fans mourned the passing of Reading's first great baseball showcase, Lauer's Park.

That darkest age of ball in Reading began, of course, during a dark period in world history.

Reading Eagle reporter Al Cartwright explained that in his lead of an August 18, 1942 story. "The return of baseball to Reading seems several years and thousands of dollars away," he wrote. "And that's a conservative effort, war or no war."

In an article that tolled the death knell for old Lauer's Park, Cartwright continued: "The diamond is in the worst shape in its history. Weeds are playing every position. The field has been sabotaged by nature. Outfielders who took their natural stance of hands on knees would almost be invisible now, so high and thick are the weeds. There's nothing so heartbreaking as those rugged weeds. You haven't seen a real bush league until you've been to Lauer's Park."

Cartwright noted that some of the stadium structure was in surprisingly fair shape: "Grandstand and bleachers, well bolstered by the free-spending J.R. (Reading Chicks) Eddington in 1940 and further improved by Brooklyn last year, are in fine shape, all things considered. The 55-cent seats still are sturdy." However, the writer predicted that any return of minor-league baseball to the storied old stadium was a long shot. "Anyone who might have some dreams about reviving baseball here would take one look at the diamond and dash for the nearest war bond."

Thus, in the summer of 1942, and for 10 more summers, nary a cheer for the home team was heard in Reading.

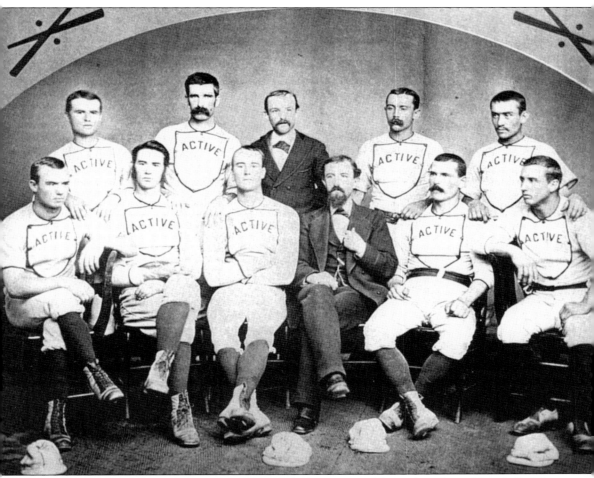

HOW IT ALL STARTED. This 1875 photograph shows one of the earliest formal baseball clubs in the city of Reading—the Actives. The Active Baseball Club was established in 1866, but it was not until 1871 that the first team took to diamonds in Reading and beyond. The first squad was made up of the best players from the Friendship, Schuylkill, and Liberty fire companies. The Actives were financed by Reading hatter Isaac N. Levan, John D. Mishler, and William Wunder. Shown, from left to right, are the following: (first row) Daniel James, right field and "assistant pitcher;" Leonard Lovett, pitcher; Jacob Goodman, first base; John D. Mishler, manager; Larry Ressler, left field; and Edward Davis, second base; (second row) Jerry Stott, shortstop; John Smith, catcher; William W. Wunder, assistant manager; Mose Dillon, center field; and Pompey Waren, third base. In the days before major and minor leagues, the Reading Actives played teams from the region as well as from Chicago, New York City, Philadelphia, and Washington, D.C. Their home field was on 19th Street between Perkiomen Avenue and Cotton Street in the city. In 1875, the Actives played 52 games against professional and amateur teams and finished with a 42-10 record. (HSBC files.)

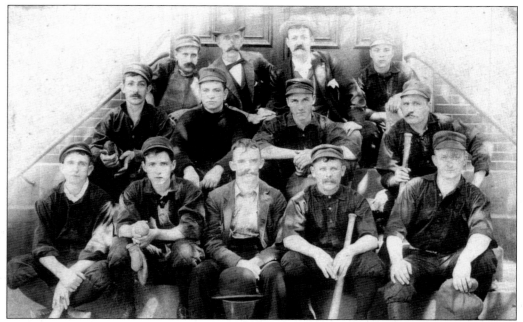

DIAMOND PIONEERS? Undated, this photograph from deep within the files of the Historical Society of Berks County may show a typical fire company team that predated the Reading Actives. Barely readable on the players' uniforms and the bucket is the word "Rainbow," which suggests it is that fire company's team. (HSBC files.)

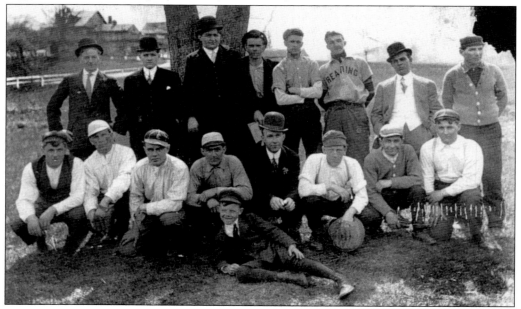

FADING PHOTOGRAPH. Sadly, this picture from Reading's baseball history is not dated, and the men are unidentified except for scattered names scribbled on the back of the photograph. However, their contribution to the game is worth pulling the picture from the dusty files and presenting it for a new generation to view. The legible names on the back include Ed Pfleger, Patrick Lillis, Walter Bobst, Paul Althouse, Paul Keim, Charles Steen, Yatti Phillipo, Bob Endy, Charles Young, and Charles Leinbach.

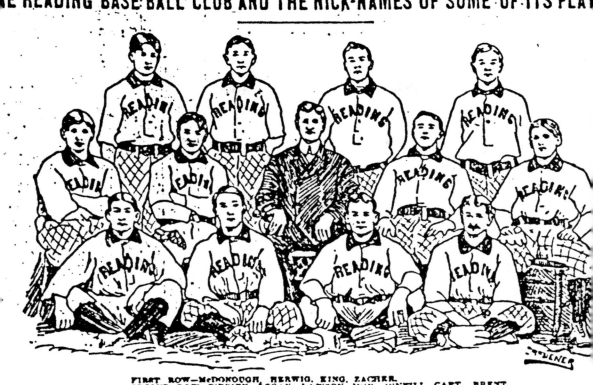

FIRST ROW—McDONOUGH, HERWIG, KING, ZACHER.
SECOND ROW—O'BRIEN, LOGAN, LAWSON, MGR. O'NEILL, CAPT., BRENT.
THIRD ROW—CLARK, O'HALLORAN, DERWIN, FOX.

THEY DID NOT KICK AT THE UMP. This drawing was accompanied by a story in the May 23, 1903 *Reading Weekly Eagle*. The story boasted not only of the on-field play of the Independent Association's Reading Base Ball Club but also of its general demeanor. "The Reading team," the reporter said, "has been doing good work on the diamond and many of the old time 'fans' have become enthusiastic. The spectators at the games have been composed of many persons who had lost interest in the sport, owing to previous failures of getting a winning team for this city. Manager Lawson has selected an aggregation of young and gentlemanly players who work harder for victory than any club that has represented this city for years. Papers in nearly all cities where they have appeared speak of their excellent conduct on and off the field. Mr. Lawson says the club is here to stay. Half a dozen local clergymen are regular attendants at the games. He has a reputation in many states as a manager who insists on good order at his grounds and one of the first things he instructs his players to do is to refrain from kicking at the decisions of the umpire." The article also offered explanations as to the nicknames of some of the players. The players are, from left to right, as follows: (front row) McDonough, "Big John" Herwig ("because of his size"), King, and "Doctor" Zacher ("because he is a medical student"); (middle row) "Jack" O'Brien, "Tommy" Logan, Manager Lawson, "Boss" O'Neill ("because he is team captain"), and Brent; (back row) "Ginger" Clark ("for the snap he puts in all games"), "Midget" O'Halloran ("because of his size"), Derwin, and Fox.

13

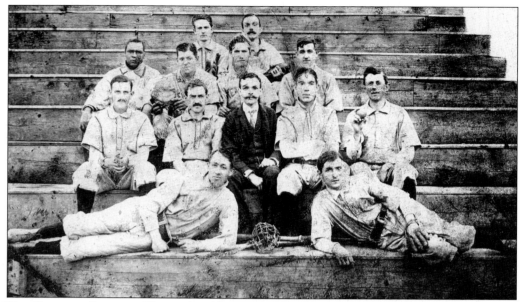

THE READING BROWNS. This undated but intriguing photograph is marked "Reading Browns." The legible names on the back include Bob McLatchie, Jim Zieber, Ed Dry, Ed Finkbone, Jim Tobin, Dutch Carver, Harry Dick, Dex Morris, Frank Hartman, and Ed Schultz. (HSBC files.)

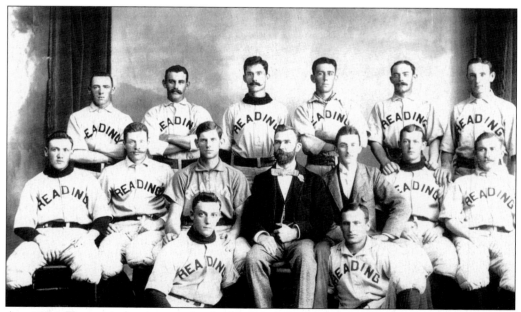

AN 1894 TEAM. A caption on the back of this photograph reads, "One of Reading's Best Teams. Member of the Pennsylvania State League, 8 teams. King Kelley played in this league." The players are, from left to right, as follows: (front row) Fox, catcher, and Goodhart, catcher; (middle row) Shinehouse, right field; Bumont, first base; Torson, captain and second base; Benn H. Zerr, manager and owner; Lindenmuth, secretary; Henry, third base; and Wetzel, shortstop; (back row) Miller, left field; Jones, pitcher; Leidy, center field; Southerland, pitcher; Coyal, pitcher; and Eustas, shortstop. (HSBC files.)

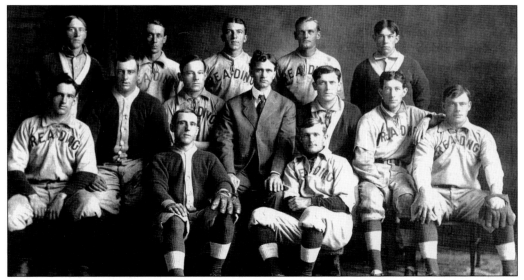

THE 1907 CHAMPIONS OF THE ATLANTIC LEAGUE. This is the Reading team that brought Reading the first pennant in the history of its minor-league activity. Only last names were given as identification. They are, from left to right, as follows: (front row) Bertwhistle, left field, and McClatchie, second base; (middle row) Britton, pitcher; Schuman, pitcher; Miller, shortstop; Lawson, manager; Rockford, first base; Connor, right field; and Biehl, pitcher; (back row) Lohr, center field; Hartman, catcher; Berry, catcher; Brent, center field; and Lee, right field. (HSBC files.)

THE READING TRI-STATE BASE BALL TEAM. In what was marked as a "Supplement to the North American" on July 5, 1908, this rendering depicts the following members of one of two minor-league teams in town that year (the other played in the Atlantic League). They are, from left to right, as follows: (front row) J.L. Weitzel (owner), Weigand (captain and manager), Cunningham, Barton, Emerson, Crooks, and Lelivelt; (back row) Stron, Boice, Clay, Hazleton, Barthold, Lynch, and Garry. (HSBC files.)

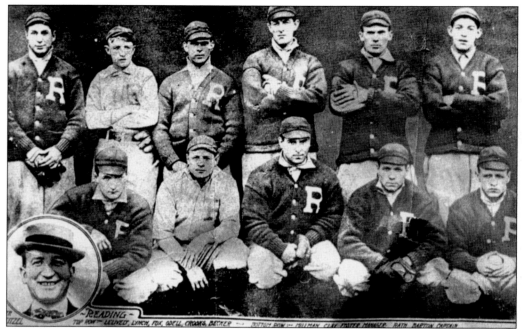

THE READING TRI-STATE BASE BALL TEAM. The following year, the Tri-State League team had this lineup, from left to right, as follows: (inset) owner J.L. Weitzel; (front row) Millman, Clay, Foster (manager), Rath, and Barton (captain); (back row) Lelivelt, Lynch, Fox, O'Dell, Crooks, and Becker. (HSBC files.)

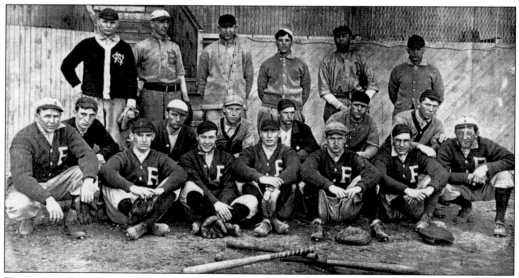

THE 1910 READING BASEBALL TEAM. In a supplement to the *New York Sunday World*, the locals of that year included, from left to right, the following: (front row) Noblit, center field; Wilson, pitcher; Shea, left field; Anderson, second base; Milliman, catcher; Murphy, catcher; and Emmerson, pitcher; (middle row) Haller, pitcher; Horsey, pitcher; Ainsworth, "outer field;" Griffith, pitcher; Ramsey, pitcher; and Dougherty, pitcher; (back row) Lane, "outer field;" Fuller, right field; Schaeffer, pitcher; Emery, shortstop; Powers, first base; and Burton, manager and third base. (HSBC files.)

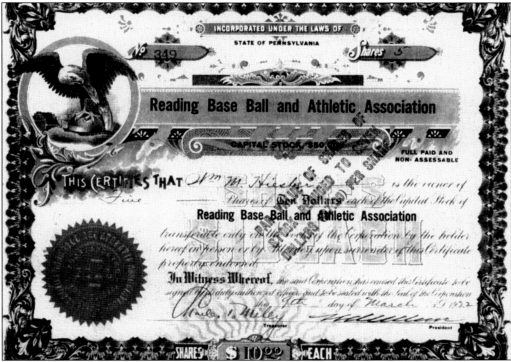

A Capital Venture. For $10 a share, investors could buy into the Reading Base Ball and Athletic Association and help fund the organization that brought International League play to Lauer's Park. The association was formed in April 1919, with the intention of raising $50,000 to support the establishment of what would become the Reading Coal Barons. This 1922 certificate from the files of the Historical Society of Berks County reveals that William H. Hiester purchased $50 worth of stock in the team on March 9, 1922.

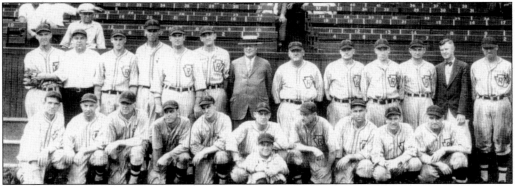

The Reading Keystones. The 1928 Keystones finished with an 84-83 record and in fourth place in the International League, but three players were sent to the International League All-Star Game: Harry "Sox" Seibold, Lou Legett, and Hobart "Rabbit" Whitman. They also drew a record of 176,668 fans to home games. Seibold's baseball career was particularly interesting. He started as an infielder with the Philadelphia Athletics in 1915 but was shipped to the minors, where he became a pitcher. He worked his way back to the Boston Braves as a pitcher but developed a sore arm. He retired twice in the 1920s but came back to play in Reading, where he led the league in wins (22) for the 1928 Keys. The next season, he was back in the majors as a starter for the Braves, where he remained until he came back to Reading in 1933.

17

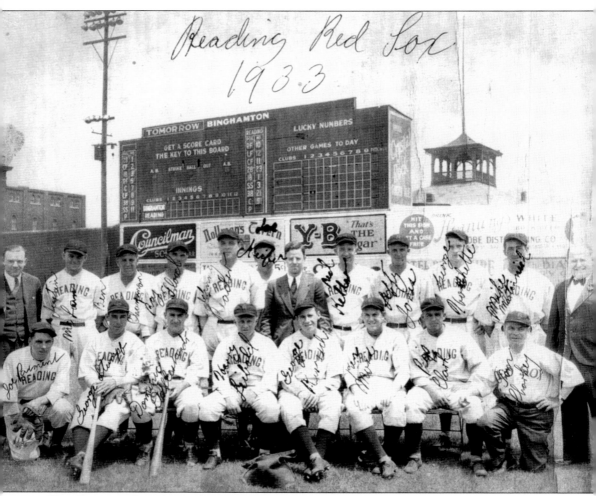

THE READING RED SOX. There was a Red Sox franchise in town in the 1960s, but there was also a Reading Red Sox team in town in the 1930s. After the Keystones bowed out of the International League after the 1932 season, baseball in the city was relegated to the Class B New York–Pennsylvania League. The 1933 Sox, under manager Nemo Leibold, finished with an 80-56 record, less than two percentage points behind first place. The 1933 team is seen in this rare photograph, with players' autographs inscribed over their uniforms (or, in Joe Keifer's case, over his face). The Boston Red Sox furnished a farm team in Reading in 1933 and 1934. Among the recognizable players in this picture are Dom Dallesandro (front row, third from left) and to his left, the aforementioned Harry "Socks" Seibold. Dallesandro led the 1933 Red Sox with 10 homers and batted .332 in 1934. The 1934 team also included former Chicago Cubs star Phil Cavarretta. Although the Cubs owned his contract at the time, they loaned him to the Red Sox minor-league system. After a .308 season in Reading, Cavarretta went straight to the majors, where he spent 21 years playing and 3 years managing the Cubs.

Two

FACES AND PLACES

To overlook Berks County when reviewing the history of baseball in Reading would be folly. The focus of this volume is indeed Reading, but baseball has flourished on every sandlot and playground in every borough and township of Berks County. The American Legion leagues, the Lebanon Valley League, high-school and college leagues, and the various recreation leagues that have included teams from the city, suburbs, and rural Berks have all been instrumental in developing outstanding players and providing entertaining ball games.

The even clearer focus of this book, toward which these opening pages lead, is minor-league baseball in Reading. It is a pictorial history of baseball in Reading and, in a lesser way, Berks County. Only cursory attention is given here to the many perennial powerhouses of Legion, high-school, and semiprofessional ball over the years. Those players, those teams, and those towns could well be the subjects of another book at another time.

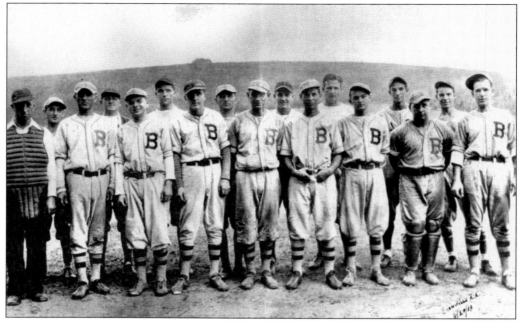

BERNVILLE. These members of the 1933 Bernville Athletic Association team are, from left to right, as follows: (front row) William Kepply (umpire), Edgar Stricker, Eugene Stump, Ralph Kline, Daniel Bagenstose, Charles Pfautz, Clifford Kline, Carl Anspach, and Frank Kline; (back row) Edgar Bright, Irvin Kirkhoff, Claude Miller, Clarence Mengel, Paul Guard, Winfield Snyder, Charles Kase, and Robert Hermansader.

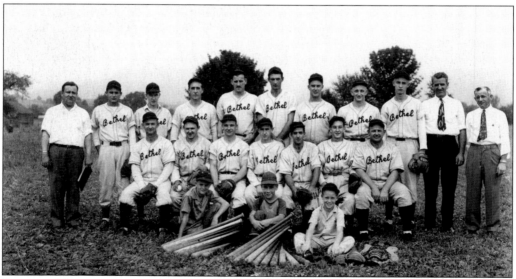

BETHEL. The extreme northwestern corner of Berks County is represented in this 1947 photograph that shows that season's Blue Mountain League champions. They are, from left to right, as follows: (front row) Sheldon Rissinger, Terry Rissinger, and Ronald Yarnall; (middle row) Fred Dubbs, John Kohr, Raymond Stamm, Richard Bean, Calvin Zellers, Paul Herrington, and Sam Schlappig; (back row) Dr. John Anspach, Richard Reed, Burt Klopp, Chester Reed, Carl Sticker, John Weidner, Skip Henne, Dick Stamm, Clayton Dubbs, Marvin Rissinger, and Robert Lutz. (HSBC files.)

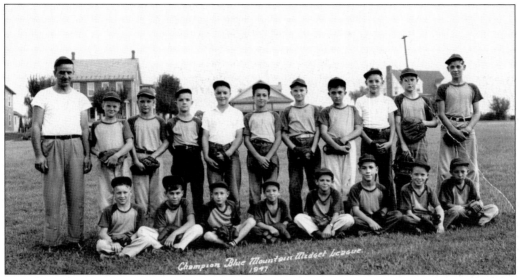

THE BETHEL MIDGETS. The Bethel Midgets were not to be outdone in 1947, when they captured the Blue Mountain Midget League championship. The team is shown, from left to right, as follows: (front row) Allen Sapore, Allen Lentz, Gene Fisher, Kenneth Wolfe, Verling Wolfe, Terry Rissinger, Ronald Yarnall, and Robert Moyer; (back row) Marvin Rissinger, Sheldon Rissinger, Phares Seiverling Jr., Ronald Morgan, Ray Tilley, Jack McHenry, Tom White, Earl Brown, Leo Forry, Orwin Keeney, and Franklin Gerhart. (HSBC files.)

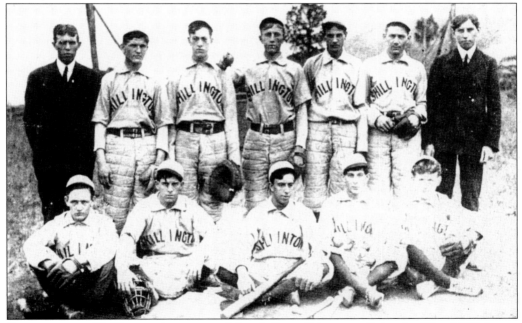

SHILLINGTON. Shillington has a proud baseball tradition on all levels. The 1905 "town team" includes, from left to right, the following: (front row) Thomas Weidner, Edwin L. Artz, Howard "Dally" Bitting, Irwin A. Artz, and Calvin Mohn; (back row) William "Hippy" Conrad (manager), Dr. Isaac B. High, James E. Wieder, William "Butch" Mohn, Frank "Haggerty" Conrad, John Gaul, and Harry "Jack" Gauss (assistant manager). (HSBC files, Charles J. Hemmig collection.)

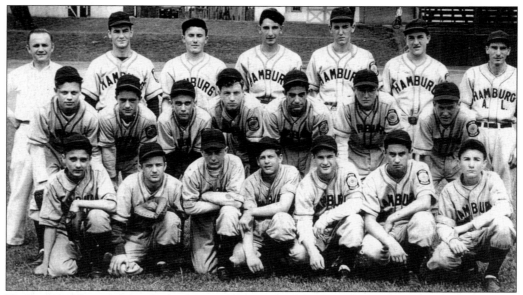

HAMBURG. The northern Berks County borough's American Legion team for the 1947 season includes, from left to right, the following: (front row) George Yoder, Tink McNeil, Stanley Henne, Robert Yoder, Robert Muller, Robert Moyer, and James Moyer; (middle row) Robert Graeff, unidentified, Howard Yoder, Holton Confer, Eugene Ortenzi, Antonio Donatelli, and Richard Yoder; (back row) George Kalbach (coach), Himmelberger, unidentified, Kermit Frantz, Douglas Romig, Neil Yeager, and Sydney DeLong.

ST. CASIMIRS. This 1920s photograph of the St. Casimirs semiprofessional team was taken at the Yellow Clay baseball diamond in Millmont. Standing in the second row, third from the right, is Joseph DeVera, and to the far right is his brother Michael "Nig" DeVera, player-manager of the team. In that era, "Nig" DeVera was the originator of the South End baseball team and was the manager of the Polish Falcons and St. Casimirs baseball clubs. In 1924, DeVera managed "Nig's Goofers," who won the semiprofessional state championship in Pennsylvania. The information was provided by "Nig" DeVera's grandson Kevin L. Devera, southeast Reading area director of the Olivet Boys and Girls Club. Ironically, he was born on his grandfather's birthday, February 16, 1963.

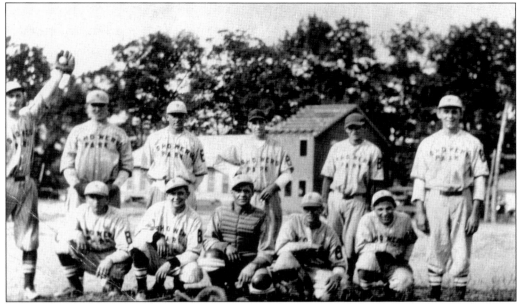

SHOWERS PARK. Playing out of Bethel, this 1929 team includes, from left to right, the following: (front row) Walter Bean, Gene Stump, Ray Weidner, Babe Ebling, and Bill Brumbach; (back row) Fred Dubb, Madison Yarnall, Norman Schlappig, Silas Kanter, Mike Kalbach, and Clarence Manbeck.

THE MUHLENBERG ATHLETIC CLUB. Shown at their old Muhlenberg High School ball field are the members of the 1936 Muhlenberg team. They are, from left to right, as follows: (front row) Warren Auchenbach, Guy Boyer, and Russ Manmiller; (middle row) Ray Boyer, George Bates, Harry Wagonseller, and Paul Heckman; (back row) Russ Swoyer, Paul Hamaker, Stan Ney, Len Gruninger, and Robert Shipe.

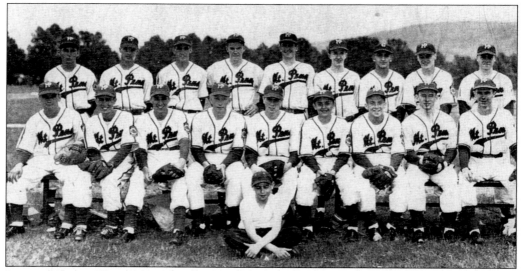

MOUNT PENN. The "Pagodas" of the American Legion Junior Baseball League represented Mount Penn in 1950. Shown here are, from left to right, the following: (front row) G. Didyoung, P. Jacobs, R. Pisano, J. Hawk, D. Shurr, B. Young, D. Stein, D. Goldman, and V. Fisher; (back row) R. Ziegler, R. Seiz, J. Bachman, R. Brown, J. Babb, B. Seaman, M. DePaul, J. McCann, and E. McCoy. The bat boy in front is T. McDevitt.

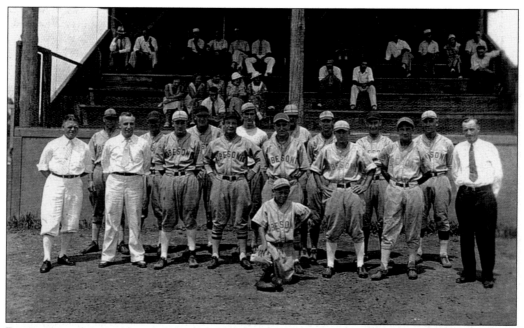

ROBESONIA. Seen in front of the grandstand of the newly opened Robesonia Base Ball Field are the 1934 Robesonia Pioneers. They are, from left to right, as follows: (front row) mascot W. Bricker; (middle row) Elwood Breigel, L. Yoder, C. Kalbach, S. Bender, L. Bertsch, P. Sallade, J. Bender, and I. Alexander; (back row) C. Krebbs, C. Nepesick, S. Klopp, B. Lord, L. Lauck, J. Green, N. Snyder, and B. Edelman. (HSBC files, Brigel collection.)

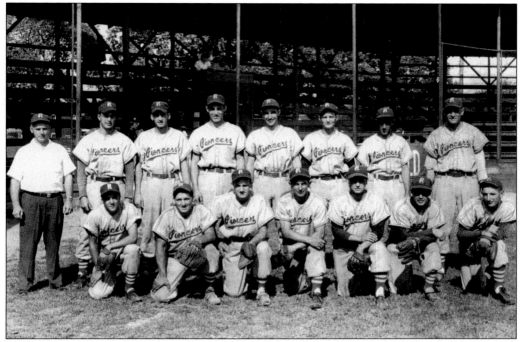

ROBESONIA. One of the Berks County representatives in the legendary Lebanon Valley League was the Robesonia Pioneers team. In this 1954 photograph are, from left to right, the following: (front row) Jerry Kramer, Bill Beidler, Dick Hoffa, Hal Putt, Babe Werner, Hal Matthew, and Charles Putt; (back row) John Lightner (manager), Otto Schnee, Harry Hoffa, Don Wealand, Bill Hefner, Norm Klopp, Bill Putt, and Stan Klopp.

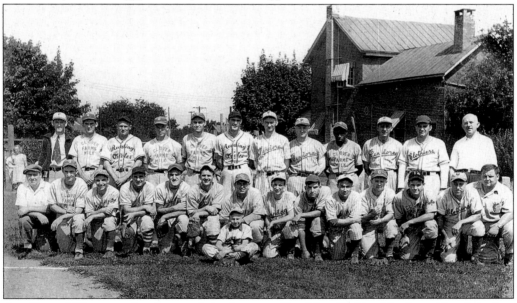

ALL-STARS? The year, the place, and the faces are all unidentified in this picture, but it is clear that the fellows represent a variety of Berks County baseball teams. Among the sponsors' names on the uniforms are Clover Farms Milk, Reading Orioles, Clothiers, and Pendora. (Sinking Spring Historical Society.)

25

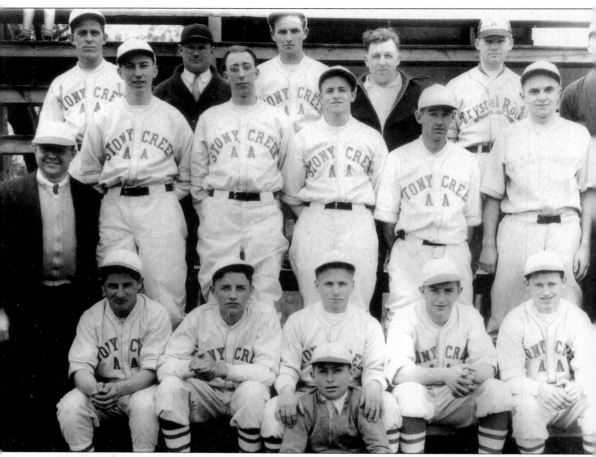

STONY CREEK AND A SURPRISE. The Stony Creek Athletic Association was chartered in the early 1920s and became quite a hub of baseball activity. At one time, three teams represented the town, including the Outlaws. Eventually, the Crystal Rock Soft Drink Company sponsored one of the teams, shown here. Players identified in this early photograph include the following: (front row) Nick Furillo, Andy Brumbach, and Mack Haudeck; (middle row) Wilbur Weaver, Woody Haver, "Mox" Lorah, "Grassy" Leinbach, "Dutch" Kershner, Elam Spatz, and Jerry Auge; (back row) Joe Martinez, Bill Steinmetz, Carl Hafer, Luther Rettner, Tom Anthony, and Bill Kercher. The bat boy in front is future major-league star and Stony Creek native Carl Furillo.

SINKING SPRING. These gents represented Sinking Spring in 1902 on a team sponsored by Pierce Steffy, a cigar manufacturer in the borough. They played their games to the rear of the mine hole on the Oberlin Estate in "Sinky." That area is now the Village Greens golf course. Shown, from left to right, are the following: (front row) John Wounderly and Mark Steffy; (middle row) Oscar Yoh, Paul Steffy, Josh Haring, and Les Wounderly; (back row) Al Bowman, A. Wounderly, Pierce Steffy (manager), Monroe Steffy, and Charles Alexander. (Sinking Spring Historical Society.)

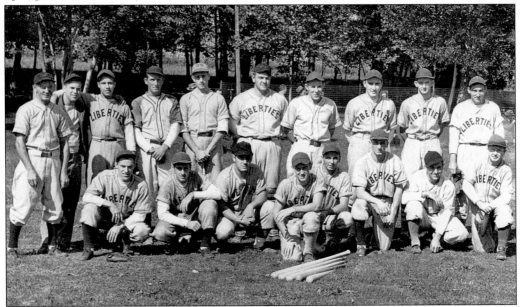

SINKING SPRING IN THE LEBANON VALLEY LEAGUE. Sinking Spring entered the Lebanon Valley League in 1947. The team members are, from left to right, as follows: (front row) Les Moyer, Harold Emerich, Pat Farra, Mud Unger, Spike Sweimler, Bobby Miller, Earl Emes, and Peachy Krick; (back row) Bill Sweimler, ? Unger, Dick Hill, Hubby Kline, Eddie Wessner, Walt Kapp, Hen Hornberger, Richard Showalter, Charley Smith, and Lou Ludwig. (Sinking Spring Historical Society.)

AN EARLY GAME AT CARSONIA. This 1905 newspaper artist's rendering depicts home-plate action and the throwing of the first ball during opening day at another of the Reading area's earliest baseball stadiums, Carsonia Park. The accompanying account reported that more than 2,000 people attended the Commercial League's season opener there. The fans were transported from the city to the Pennside grounds by Reading Traction Company trolleys, which ran at full capacity every four minutes prior to game time. Teams in the league at that time included Schuylkill, All-Scholastic, the Reading Grays, and the Amphions. The game was preceded by a parade from downtown Reading to the park, highlighted by the appearance of five horseless carriages, including two "hill-climbing machines" made by Reading's Duryea Power Company.

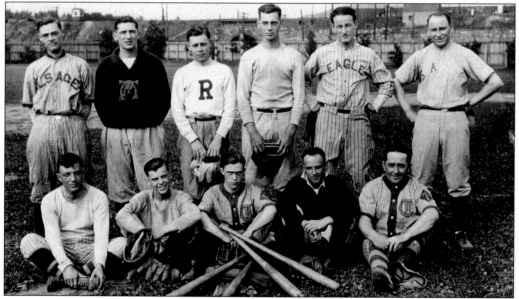

ALL-STARS. Little is known about this assemblage, which seems to be an all-star team from a city-county league in 1924. It is apparent, however, that the photograph was taken at George Field, longtime home of the Reading High School and American Legion baseball teams.

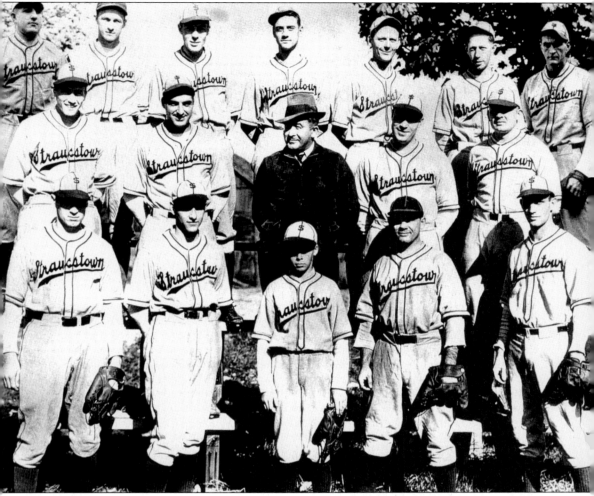

STRAUSSTOWN. This team represented Strausstown in the Lebanon Valley League in 1934. From left to right are the following: (front row) George Swoyer, Elmer J. Riegel, Leon "Red" Himmelberger, Walter "Perry" Rothenberger, and John L. Stine; (middle row) Charles T. Wagner (yes, Charlie Wagner), Anthony "Tony" Machione, Elmer B. Miller (business manager), Le Roy Sponagle (manager), and Samuel Schlappich; (back row) Irvin L. Bressler, William P. Coombs, Arthur S. "Lefty" Haas, Robert Katz, Babe Fidler, George H. "Red" Schappell, and Miles D. "Mickey" Herring.

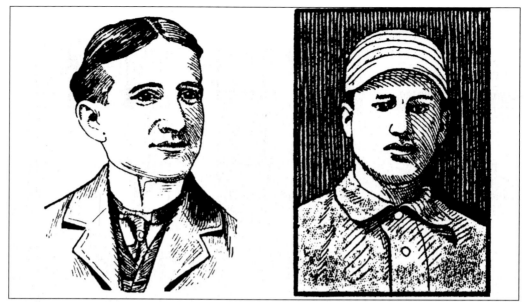

PIONEERS. On the left is Jacob L. Weitzel, who played ball in Reading as the game was being developed and went on to become a leader in the formation of teams and leagues just after the turn of the century. In 1904, he organized the Vigilant team of the Liberty Fire Company and then became manager of the All-Scholastic team in the City League in 1905. Two years later, he brought Tri-State League ball to Reading. On the right is George Goodhart, the captain of Weitzel's 1905 All-Scholastic team. The team had nothing to do with "scholastic" baseball as we know it today. It was made up of amateur and semiprofessional players. Some had been in the game for many years. Goodhart, for example, started his career in Lancaster in 1890 and then played in Harrisburg and Scranton; Portland and Lewiston, Maine; Charleston, South Carolina; Bloomsburg and Youngstown, Ohio, before returning to his hometown.

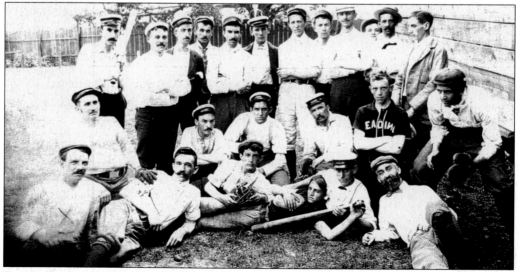

DIVES, POMEROY AND STEWART. The longtime main department store on Penn Street in Reading—Dives, Pomeroy and Stewart—was also an early supporter of baseball in the city. Among the earliest known pictures of a baseball team in town is this 1883 photograph of the Dives, Pomeroy and Stewart team. (HSBC files.)

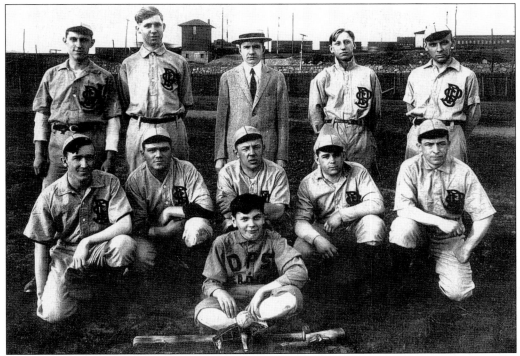

DIVES, POMEROY, AND STEWART, 1914. The railroad yard in the background leaves no doubt that this picture of the Dives, Pomeroy and Stewart team was taken at George Field. The only identifiable person in the photograph is team manager John J. Roth, who is wearing the suit. (Brian Roth.)

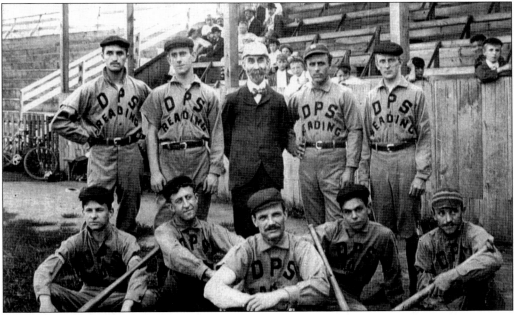

THE DIVES, POMEROY AND STEWART NINE. Unless the chap in the suit played, there were only nine men on the roster of this Dives, Pomeroy and Stewart team. Third from the left in the front row is Bill Kline. (HSBC files.)

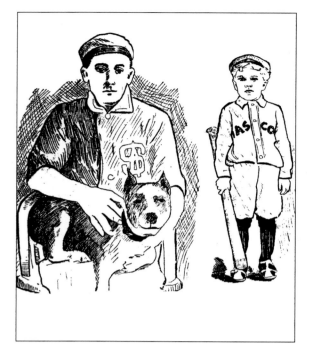

MASCOTS WERE DIFFERENT THEN. Anyone who attends modern baseball games is familiar with modern-day team mascots. In 1906, the six-year-old boy on the right and the 34-pound English bull terrier on the left were mascots of two teams in Reading's Commercial, or City, League. The boy is Harold Rohrbach, son of William Rohrbach, who was the official umpire of the league. The first-grader wore the mascot uniform of the Reading Grays. The dog is Dot, mascot of the league's All-Scholastic team. He is seen with his owner, John Mauger, star outfielder and "reliable batsman" of the All-Scholastic team. Mauger was a veteran of the old Reading Actives team and, according to a newspaper account, "had a hard time keeping the animal from following him to the outfield between the innings."

LOOKING FOR A GAME. Although the young men in this 1910 photograph are not identified, the setting is pure Reading and the game on their minds is purely baseball. (HSBC files.)

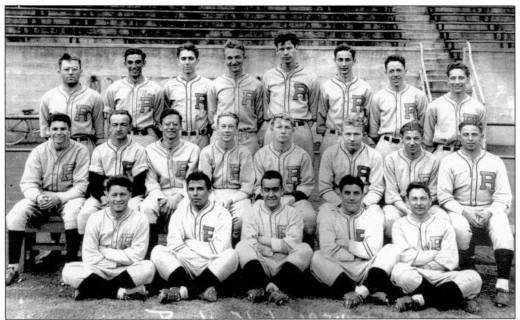

THE 1934 RED KNIGHTS. Some keen-eyed reader is likely to find a long-lost friend or relative among the bright faces of this Reading High School baseball team. The picture was taken in front of the grandstand of George Field, longtime home field of the Red Knights. (HSBC files.)

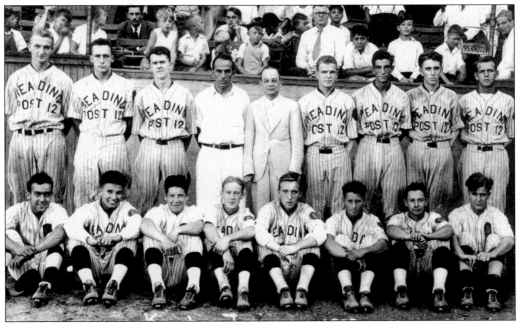

GREGG POST, A PERENNIAL POWERHOUSE. Team members in this photograph are not identified, but they represent the Keystone Juniors, the 1933 Pennsylvania American Legion and Region 10 baseball champions. Legion Post No. 12 is officially "Gregg Post," having been named that after the death of Indian fighter, Civil War hero, and Reading resident Maj. Gen. David M. Gregg. (Flannery files.)

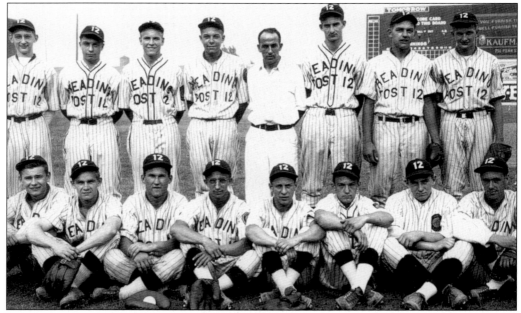

THEY DID IT AGAIN. The Gregg Post team took the state American Legion championship again in 1936. The members of that team are, from left to right, as follows: (front row) Mike Tomczewski, Lucian Jablonski, Peter Topala, John Maslar, Norman Hanley, Karl Bachman, Wilbur O'Neil, and Tony Grillo: (back row) Claud Keim, Raymond Ohlinger, Donald Stahl, Harold Tase, coach "Doc" Silva, Sherwood Werner, Joe Bonnigut, and Frank Jakobowski. (Flannery files.)

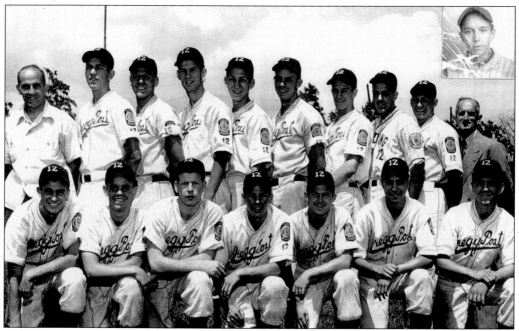

. . . AND AGAIN. These members of the 1944 state champions from Gregg Post are not identified, but their bat boy earned his own spot with his picture pasted in the upper right of the photograph. (Flannery files.)

34

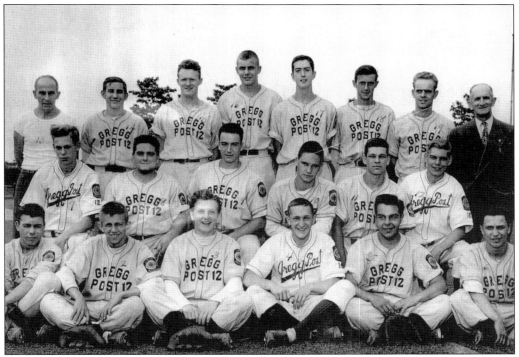

. . . AND STILL AGAIN. The 1947 version of the Gregg Post squad brought the state American Legion championship back to Reading. The team includes, from left to right, the following: (front row) Florin Harbach, Richard Knoblauch, Harry Storch, Ray Reifsnyder, Harold Sell, and Ron Farina; (middle row) John Witmoyer, Dave Lattanzio, George Himmelreich, George Weaver, Frank Heller, and Dick Nein; (back row) "Doc" Silva (coach), Bill Schmehl, Joe Reedy, Conrad Dettling, Charles Tulley, Tom Moore, Milan Kemp, and Harry Reichlein (athletic director). (Flannery files.)

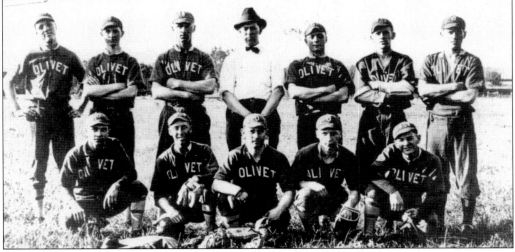

THE OLIVET BOYS CLUB. Now the Olivet Boys and Girls Club, this venerable institution has been a longtime supporter of baseball on the playgrounds and sandlots of Reading. This rare photograph shows the club's 1914 recreational league city championship squad. (Olivet collection.)

THE OLIVET BOYS TEAM. Another rare photograph from the Olivet Boys and Girls Club files, this picture is undated. (Olivet collection.)

THE 1916 OLIVET BOYS CLUB. Little is known about the members of this squad, other than the names "Hoagy" and "Butch," which were scrawled beneath the original photograph. (Ralph O. Bigony, Olivet collection.)

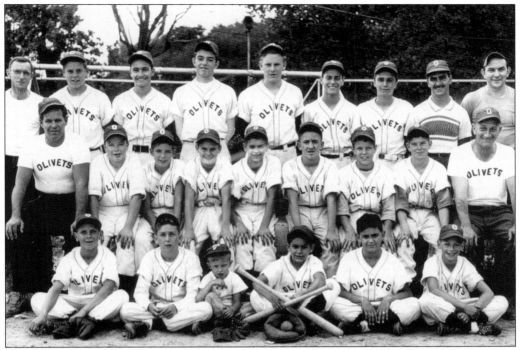

MIDGET CHAMPS. This team carried the Olivet name all the way to the City-County Midget baseball league championship in 1951. (Olivet collection.)

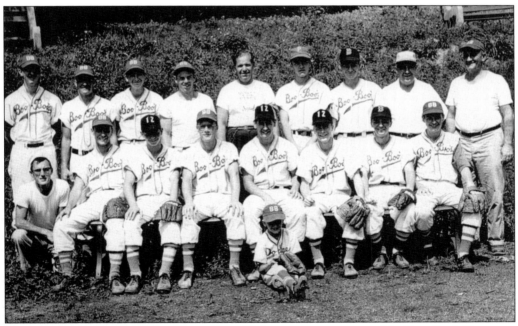

BOO-BOO'S. Teams out of the Olivet Boys Club were once sponsored by Boo-Boo's Tavern, a popular Cotton Street pub. This undated photograph appears to have been taken at the Baer Park ball field. (Olivet collection.)

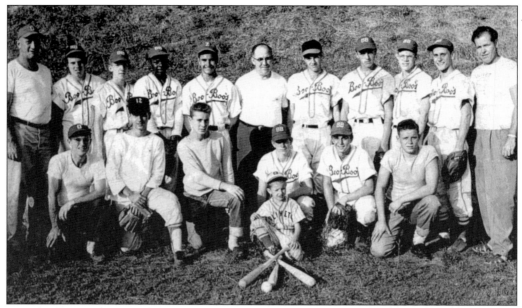

BOO-BOO'S, TOO. The 1953 Olivet Boys Club team sponsored by Boo-Boo's Tavern won the county Class C League championship. In the center is William "Boo-Boo" Leonardziak, proprietor of Boo-Boo's Tavern and longtime Reading city councilman. (Olivet collection.)

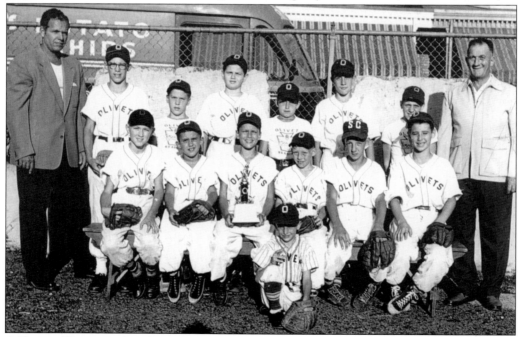

A PROUD HISTORY. Another Olivet Boys Club team is seen in this undated photograph. The Olivet Boys and Girls Club was deemed so important to baseball in Reading that on March 4, 2002, it was in the Olivet's Oakbrook facility where the Reading Phillies declared that they had acquired the legal trademark of "Baseballtown" and announced the formation of Baseballtown Charities. The first official act of Baseballtown Charities was to back Olivet's Revitalizing Baseball in the Inner Cities program. (Olivet collection.)

Three

HOMETOWN HEROES

They came from the steel foundries, the hosiery mills, and the farms. They came from sandlots, street corners, and schools. Some came with big dreams, some with small hopes. All of them came to do what they did best—play baseball. Baseball was more than America's pastime for these young men. It provided a stage upon which they could perform and pursue those hopes and dreams. Some went on to feel the thrill of getting a clutch hit or homer to win it all. Others ground their way through agonizing seasons and returned to the foundries, farms, streets, and schools.

There were seasons that ended with fireworks and a pennant, and there were years such as 1926, when Reading's Keystones finished with a 31-129 record. No matter who they were, no matter where they came from or where they went to, these ballplayers and these teams built the foundation upon which eventual Hall of Famers stood tall. Each one of them in their own way contributed to Reading's national prominence as Baseballtown.

Hundreds of faces and names will unfold in the following pages. Only a few will be readily recognizable even to the most ardent baseball fan. However, every one of those young men donned a cap, grabbed a glove, and upon hearing the plaintive call of "play ball," they did just that.

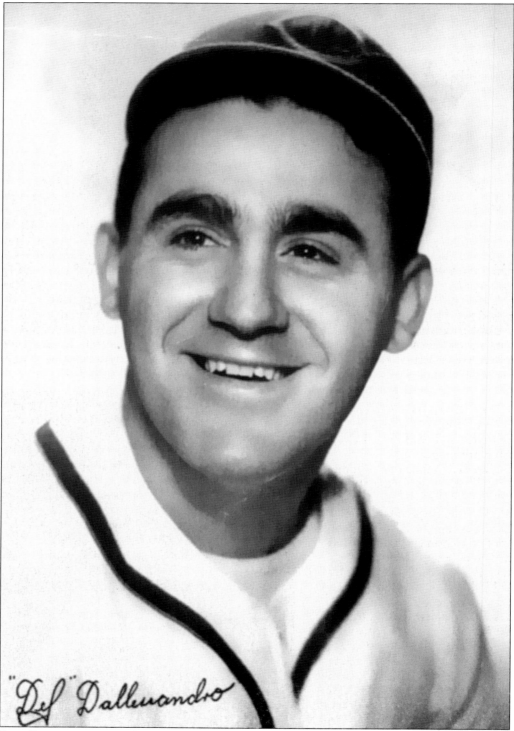

DOM DALLESSANDRO. The smiling Dom Dallessandro had several nicknames, as witnessed on this photograph autographed by "Del" Dallessandro. Dom or Del, they are one and the same. (Reading Phillies files.)

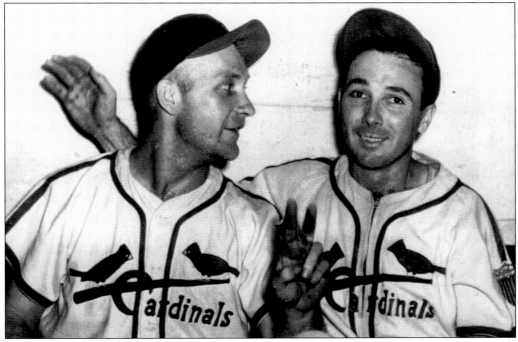

THE CARDS' HOME RUN DUO. Reading's George "Whitey" Kurowski (left) and Cardinals center fielder Buster Adams congratulate each other in the dugout after their seventh-inning home runs in June 1945. (*Reading Eagle* files.)

WHITEY KUROWSKI. Third baseman George "Whitey" Kurowski is probably best known for his two-run ninth-inning home run off Yankee Red Ruffing that won the 1942 World Series for the St. Louis Cardinals. He wound up with three World Series rings and a career batting average of .286. Kurowski went on to manage for 15 years in the minor leagues, including the 1965 Reading Indians. Despite his World Series heroics and illustrious career, his debut in the majors was less than impressive. An article in the *Reading Eagle* from September 24, 1941, read, "Down with the St. Louis Cardinals in that 4-0 defeat in Pittsburgh yesterday went George (Whitey) Kurowski, Reading third baseman recently purchased from the Rochester Internationals. In the first time he ever batted in a major league game, Kurowski took three healthy swipes and struck out."

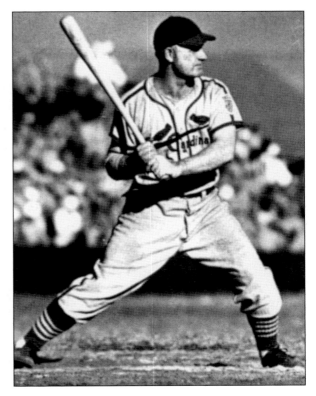

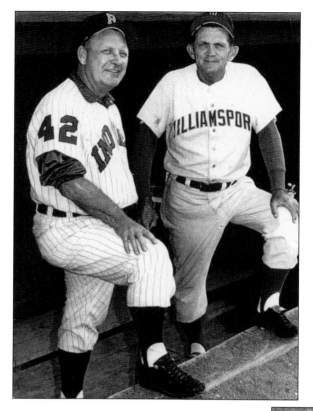

SKIPPERS. Whitey Kurowski (left), manager of the 1965 Reading Indians, chats with former Indians' skipper, then at the helm in Williamsport, Kerby Farrell. (HSBC files.)

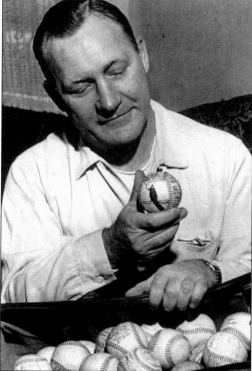

REFLECTING. After his World Series–winning homer, Whitey Kurowski was given a hero's parade up Penn Street in downtown Reading. City schoolchildren were given a half-day off to witness the event. (HSBC files.)

CARL FURILLO. Nicknamed "the Reading Rifle" (or "the Arm" or "Skoonj"), Stony Creek Mills native Carl Furillo played eight games of the 1940 season with the Inter-State League Reading Chicks. However, he made his mark as a career .299 hitter and a member of seven National League and two World Series champion Dodgers teams, in both Brooklyn and Los Angeles. (Flannery files.)

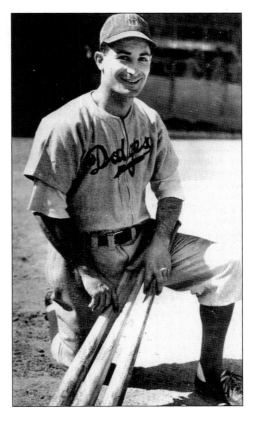

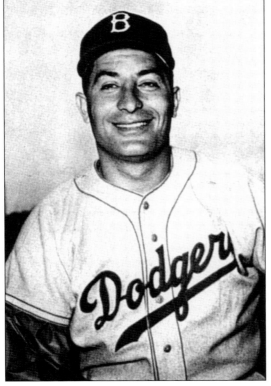

THE READING RIFLE. Before making it to the majors, Carl Furillo played locally with the St. Lawrence Dairy, Leesport, and Oley sandlot teams. After his great career with the Dodgers, he returned to Reading and coached American Legion ball. (HSBC files.)

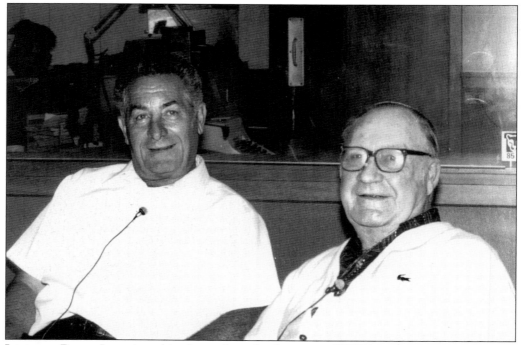

LOOKING BACK. Interviewed in the studios of radio station WEEU in the 1980s, Carl Furillo (left) and Whitey Kurowski reflected on their baseball careers. (WEEU files.)

MONOCACY'S FINEST. Randy Gumpert of Monocacy broke into baseball in a big way. Right after graduation from Birdsboro High School, he joined the Philadelphia Athletics and went 1-2 as a reliever for the 1936 Athletics. He had a 17-year career in the majors and minors and went on to coach in the minors and scout for the New York Yankees.

RANDY GUMPERT. Randall Pennington Gumpert was a lanky hurler from Monocacy who played for the Birdsboro American Legion team before making it to the majors. Seen here in his Chicago White Sox uniform, Gumpert went 13-16 for the 1949 Sox. He also had a 4-1 record for the 1947 Yankees, who won the World Series.

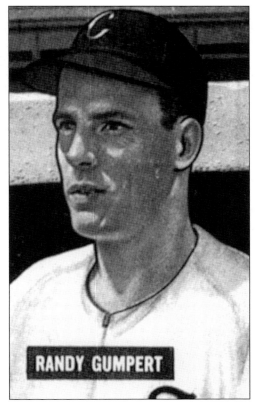

DICK GERNERT. The strapping first baseman honed his skills with the Reading High School and Gregg Post American Legion teams and had 11 major-league seasons before winding down his playing career with the Reading Red Sox in 1963 and 1964. Gernert coached in the minors and for the Texas Rangers and became the director of player development for the New York Mets.

STAN WENTZEL. Stan Wentzel, an Exeter Township native, worked his way through various recreational leagues in Berks County before making it to the Boston Braves at the end of the 1945 season. His brush with big-league glory was flanked by several good years in the minors as a player (with a lifetime average of .301) and manager. (HSBC files.)

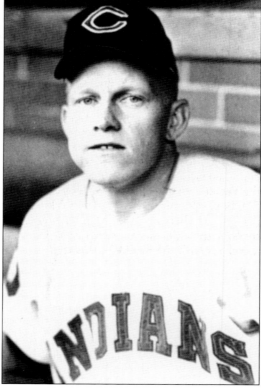

CARL MATHIAS. A pitcher for the Cleveland Indians (1960) and Washington Senators (1961), lefty Carl Mathias was a product of Oley High School, where he pitched six no-hitters. He was also a standout basketball player at Oley. His baseball climb to the majors was via the Boyertown American Legion team and, in 1957 and 1958, the Reading Indians.

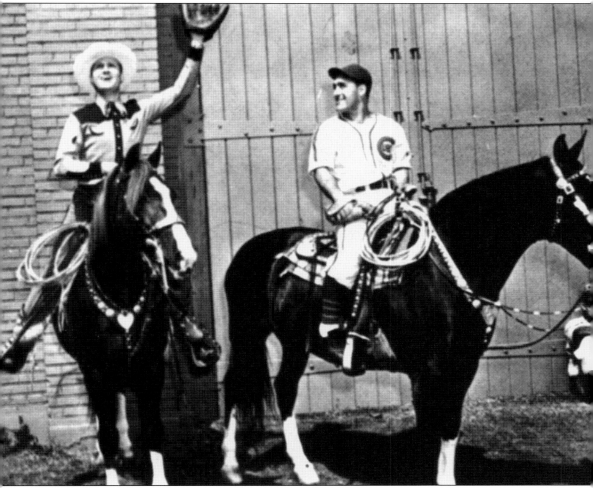

DOM DALLESSANDRO. Nicholas Dominic Dallessandro, also known as "Dim Dom" and "Mr. Five by Five," came out of the Gregg Post Legion program and had a seven-year career with the Chicago Cubs after a one-year stint with the Boston Red Sox. At only five feet six inches tall, Dallessandro was tough to strike out, and his best year with the Cubs was 1944, when he hit .305. His minor-league career, which included two years (1933 and 1934) for the New York–Pennsylvania League Reading Red Sox, was highlighted in 1937, when he was traded to the Pacific Coast League San Diego Padres along with four others from the Boston Red Sox. The Sox, in return, got a 19-year-old kid named Ted Williams. The trade worked out well for San Diego, where, in 1939, Dim Dom won the Pacific Coast League batting title. His closest rival for the title was another Dom—Dom DiMaggio. Here, Gene Autry clowns around on horseback with the Reading ballplayer.

HARRY SCHAEFFER. Harry Schaeffer, a Shillington High School and Shillington Red Sox star, made his way through the minors starting in 1946 until he got the call from the New York Yankees in 1952. He returned to the minors for a couple more seasons and came home to coach the Cocalico High School basketball team.

GEORGE EYRICH. Gregg Post and Reading High standout George Eyrich went right from the Castle on the Hill to Philadelphia, where at 18 years old he made his first appearance in relief for the Phillies. After one season there, he went on to kick around in the minors until 1954. He moved back to Reading, where he served many years as president of the Reading Hot Stovers.

DOUG CLEMENS. A baseball and football star at Muhlenberg High School in the mid-1950s, outfielder Doug Clemens had a nine-year career in the majors, including stops at St. Louis, the Chicago Cubs, and the Phillies. In 1966, he tied a major-league record by smacking three straight doubles as a pinch hitter.

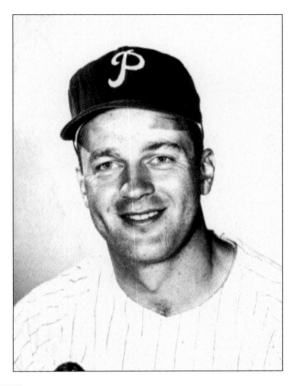

STANLEY "BETZ" KLOPP. Stanley "Betz" Klopp is perhaps the only major-league player ever named after a cow. The Robesonia High School graduate worked his way through semiprofessional and minor-league ball until a scout signed him to the Boston Braves in 1944. There, he went 1-2 in 24 relief appearances. As for the nickname, legend has it that there was one cow on the farm he was raised on that would only allow Klopp to milk her. Her name was Betzy, and Stanley became "Betz."

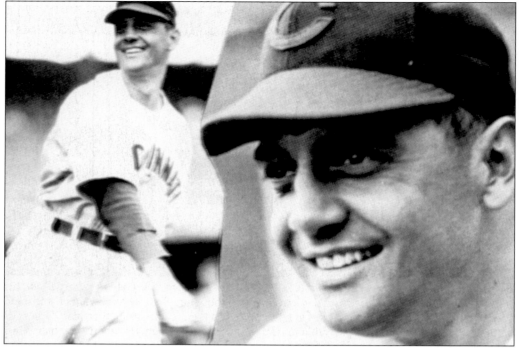

BOB KATZ. Lancaster native Bob Katz became a Reading resident in 1927, when he was 16 years old. He played for the Strausstown team of the Lebanon Valley League and was signed by the Boston Red Sox. They shipped him to the minors, where he played for eight seasons. His shot at the majors came in 1944 with the Cincinnati Reds. He appeared in six games, went 0-1, and was sent back to the minors in Syracuse. On two occasions in 1945, he pitched complete games for both games of doubleheaders.

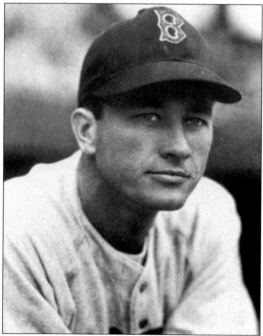

CHARLIE WAGNER. Charles Thomas Wagner came from the sandlots of Reading and went on to become the acknowledged "King of Baseballtown, USA." His major-league career included six years on the Boston Red Sox roster, where he compiled a 32-23 record. He would have had two more seasons, but World War II and a stint in the navy interrupted his stay with the Sox in 1943 and 1944. He retired as an active player in 1946 but continued to serve in the organization as pitching coach, scout, and in the player development program. The Red Sox honored Wagner in 1998 by naming the entrance to their minor-league training facility in Sarasota, Florida, Charlie Wagner Way. The press box at Reading's FirstEnergy Stadium, the home of the Reading Phillies, was named in his honor in 2002. The Reading Phillies also honored Wagner as the first King of Baseballtown at a 2002 banquet.

TALKIN' BASEBALL. Charlie Wagner (center) got his nickname "Broadway Charlie" for his penchant for snazzy suits and sartorial splendor. In this photograph, however, Wagner gets some competition from the nattily attired Dick Gernert (left) and none other than the "Splendid Splinter" himself, Ted Williams. Williams and Wagner were roommates when they played for the Boston Red Sox. (*Reading Eagle* files.)

VIC WERTZ. Born in York, Vic Wertz's family moved to Reading when he was 11, and he was a star for Gregg Post and Reading High School before he was signed to a minor-league contract in 1942. He made it to the Detroit Tigers in 1947. He played for the Tigers through 1952 and then for the St. Louis Browns, Baltimore Orioles, Cleveland Indians, Boston Red Sox, the Tigers again, and the Minnesota Twins before he hung up his spikes in 1963.

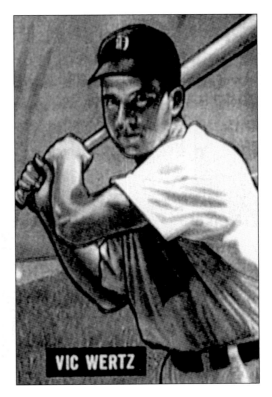

VIC WERTZ

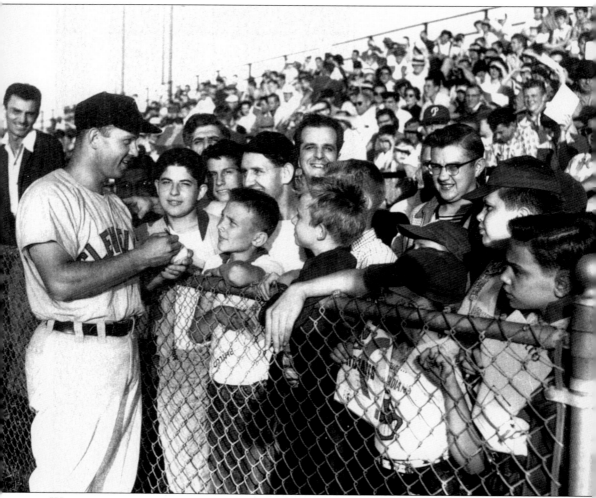

WORKING THE CROWD. During a Reading Indians–Cleveland Indians exhibition game at Municipal Stadium in 1954, hometown hero Vic Wertz takes time to sign autographs for young fans. A three-time major-league All-Star, Wertz wound up with a career .277 average and 266 homers. Wertz was robbed of a hit by Willie Mays when the "Say Hey Kid" made a famous over-the-shoulder catch in the 1954 World Series.

JUST PASSING THROUGH. The next sequence of photographs represents the faces of ballplayers who came to play in Reading during the city's years in the International League. Many of their names have faded into faint memory. Here, Dan Taylor takes a swing of the bat with the Reading Keystones logo clearly visible on his shirt.

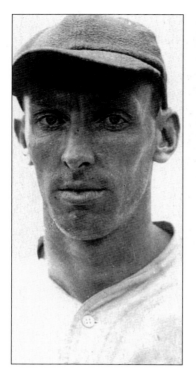

CY TURNER. Another Reading Keystones player, Cy Turner played at Lauer's Park in the early 20th century.

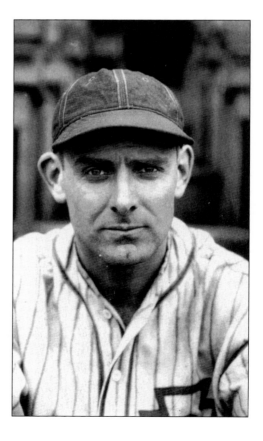

CLAYTON VAN ALSTYNE. Clayton "Spike" Van Alstyne, who played for the Reading Keystones in the 1920s, made it to the big leagues in 1927 and spent two years with the Washington Senators. He pitched in six games in those two seasons and had no decisions.

JAMES WILTSIE. James Wiltsie is pictured here in the 1920s.

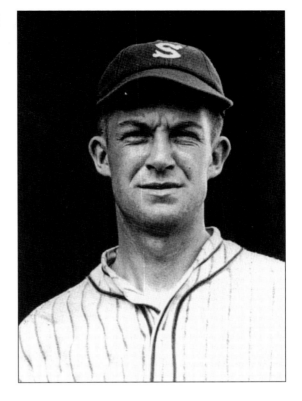

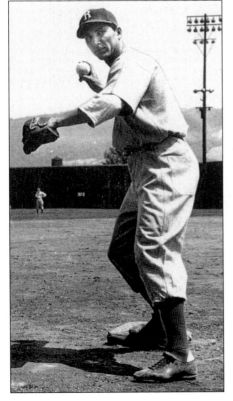

AL CAMPANIS. Yes, this is *the* Al Campanis, baseball fans. Before his less-than-illustrious major-league career (second base for the Brooklyn Dodgers in 1943, seven games, .100 batting average), before working for the Dodgers for 46 years, and before being unceremoniously fired for making insensitive racial remarks on national television in 1987, Campanis toiled for the Reading Keystones.

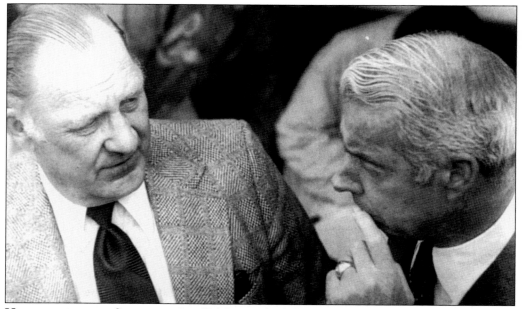

HARDBALLER FOR SOFTBALL. Joe DiMaggio (right) turned out for the inauguration and opening day of the Reading-based Pennsylvania Liberties women's softball season in 1976. The Liberties were one of 10 original teams (Connecticut, Buffalo, Chicago, Michigan, San Jose, San Diego, Southern California, Santa Ana, Phoenix, and the Liberties) in the International Women's Professional Softball Association (IWPSA). (Photograph by the author.)

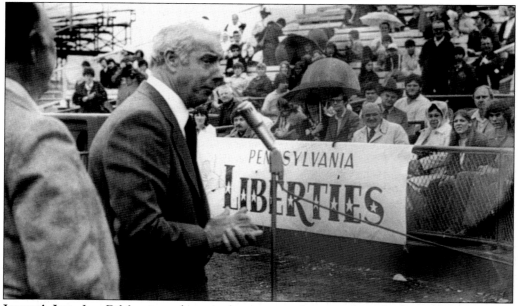

JOLTIN' JOE. Joe DiMaggio welcomes the opening-day crowd to the inaugural season of the Pennsylvania Liberties, who played at a softball-rigged Municipal Memorial Stadium. The women's professional softball league was founded in 1976 by Ladies Professional Golf Association golfer Janie Blaylock, softball legend Joan Joyce, and tennis star Billie Jean King. The teams played a 120-game schedule (60 doubleheaders) and survived only four years. (Photograph by the author.)

Four

BUILDING A
BETTER BALLPARK

What has been hailed as one of the finest minor-league baseball stadiums in the United States had a rocky start. Although the Reading city council of the late 1940s seemed intent on building the facility not only for baseball use but for other purposes, there was stiff opposition to the expenditure. However, as the sun slowly rose on the "modern era" of professional baseball in Reading, the stars came out and cast a brilliance that saw the stadium and its supporters through those initial lean years. It was actually on October 3, 1950, in midconstruction of Municipal Memorial Stadium, that the first baseball luminary paid a visit.

Carl Hubbell, the screwball-tossing Hall of Famer, met with Mayor John F. Davis and stadium officials to discuss the very real possibility that the city's hopeful return to minor-league ball might materialize in a very big way. Hubbell, who made one of his many marks on the game when he struck out (in order) Babe Ruth, Lou Gehrig, Jimmy Foxx, Al Simmons, and Joe Cronin in the 1934 All-Star Game, was in Reading as the director of the New York Giants farm system.

With the stadium about 60 percent complete, Hubbell told the mayor that Reading was on a short list of cities that would replace Jersey City as the location for the Giants' farm team in the International League. Jersey City had failed to attract even 75,000 paid customers in 1949, Hubbell said, and its franchise at the top level of minor-league baseball was doomed.

While in town, the 47-year-old Hubbell remembered when he pitched at the old Lauer's Park stadium as a member of the Toronto team. That was 1926, when Reading fielded a team in the International League. The dream that another International League franchise might be granted to Reading never came true. However, in those tentative years between the construction of the stadium and the ultimate realization of the return of baseball, the very brightest body in the baseball galaxy shone a bright light on Reading's diamond hopes.

He had been governor of Kentucky and a U.S. senator from the Bluegrass State, but more than that, he had succeeded the legendary Kenesaw Mountain Landis as commissioner of baseball in 1945. Albert Benjamin "Happy" Chandler honored Reading as the keynote speaker at the July 15, 1951 formal dedication of Municipal Memorial Stadium. The commissioner's appearance was the fulfillment of a promise he had made five years earlier when he spoke to the Old Time Baseball Committee (also known as the Oldtimers), a baseball support group that was instrumental in lobbying for a new stadium in the city.

Much historical water—some turbulent—had surged under Chandler's bridge in the intervening years. He was decisive when major-leaguers attempted to flee into the Mexican League. He dealt swiftly with certain owners who believed they wielded more power than the commissioner. It was on his watch that a Players' Pension Fund was established and Major League Baseball was integrated.

A mile-long parade on Centre Avenue from Spring Street to the stadium drew thousands of spectators on dedication day. The units included members of the Oldtimers and the Combined Veterans' Council of Berks County, which organized the stadium ceremony. Although the temperature topped 90 degrees, some 3,000 people were in attendance at the ballpark for what was to be a two-hour program. Chandler's address touched on the post–World War II state of baseball on all levels.

"The minor leagues were in a poor condition at the close of the war," lamented Chandler, "and the majors were not too good either. That is why I began an intensive campaign to put the sport back on its feet. Baseball was dead at the grass roots in 1944 when I stepped into the position vacated by Landis. I began to tour the country then to help put the game back on its feet. This I did only because I felt it was important. My salary as commissioner was never of importance to me. I love the game and worked only for its best interest and not my own while in the commissioner's seat."

Happy Chandler's address was also his swan song as baseball commissioner. His contract had not been renewed, and he was in the process of retiring from the top office. "This is my valedictory to baseball, at least for the present," he said. "I am closing the door on baseball, but not completely." He left baseball to return to Kentucky, where he was elected to a second term as governor. In 1982, he was elected to the Baseball Hall of Fame.

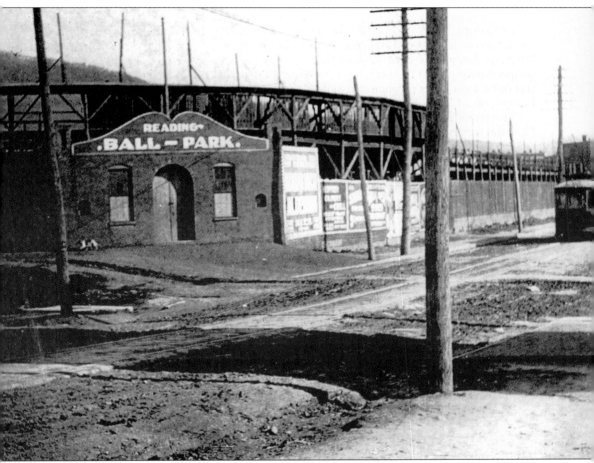

THE CORNER OF 11TH AND AMITY STREETS. The Reading Ball-Park stood briefly at what is now the site of the 11th and Pike Playground. The main entrance, pictured here, was on the southeast corner of 11th and Amity Streets. Reading's Tri-State League teams played here from 1907 to 1911. Another baseball field, at 19th and Cotton Streets, was one of the most heralded parks in town when it was announced in the September 11, 1874 *Reading Eagle:* "Col. Hawman has a large force of men at work grading the Actives' new ground at 19th and Cotton Streets. The work is under the superintendence of P.A. Fritch, which is a sure guarantee of its being well done. The fence is also being put up." However, when the Actives opened their season at their new home, they were clobbered by the Philadelphia Pearls 15-0. (HSBC files.)

THE CIRCUS MAXIMUS. Tri-State League teams played in this stadium in 1912 and 1914. When the International League extended an offer to Reading to provide a franchise in 1919, a 20-man team was hastily assembled and "Red" Dooin, former Philadelphia Phillies manager, was hired as skipper of the new Reading Coal Barons. Their practices were held at the Circus Maximus, circus grounds built by Reading builder and baseball team owner William Abbott Witman. (His accomplishments include the Pagoda.) The International League team improvised on the all-purpose field and played their first several games on the road until Lauer's Park could be improved and expanded. The Circus Maximus was demolished to make room for the Albright College football stadium, now Shirk Stadium. Albright College's baseball coach, Charles "Pop" Kelchner, was the first business manager of Reading's International League team. The college's baseball field, a block east from the football field, is named after Kelchner.

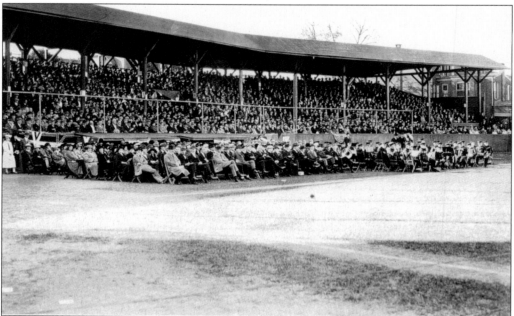

LAUER'S PARK. Reading's first minor-league ballpark was also used for other major civic functions from time to time. This 1923 photograph shows the main grandstand and infield packed with citizens gathered for what was billed as a "Religious Mass Meeting" on Founders' Day during the city's 175th-anniversary celebration. (HSBC files.)

A STRAW HAT KIND OF DAY. Note the headgear of the fans in this rare closeup of the stands at Lauer's Park. Two members of the St. Casimirs semiprofessional club are seen nonchalantly warming up in this picture from the 1920s. This photograph was provided by Edward "Flip" DeVera and Ramon "Cat" Devera, sons of Michael "Nig" DeVera, player-manager of the St. Casimirs team.

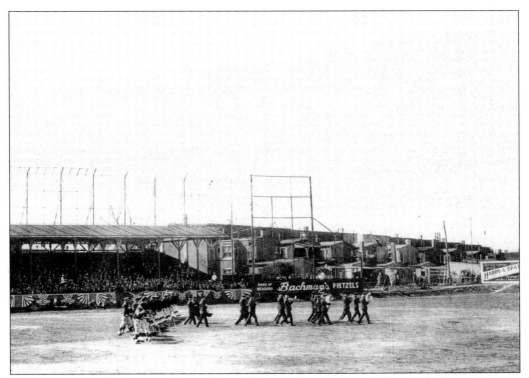

STRIKE UP THE BAND AND PLAY BALL. The row houses around Lauer's Park stadium are clearly visible in this picture that depicts the start of another baseball game. (HSBC files.)

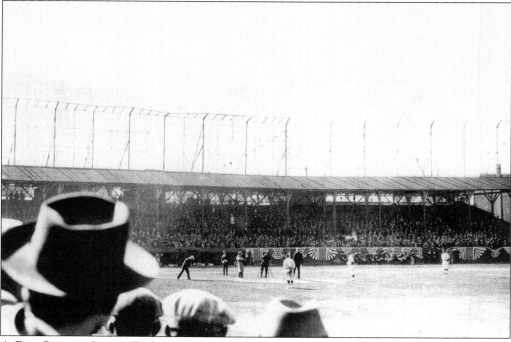

A Big Crowd. Lauer's Park appears to be packed for a game in this undated photograph by Paul L. Glaser. (HSBC files.)

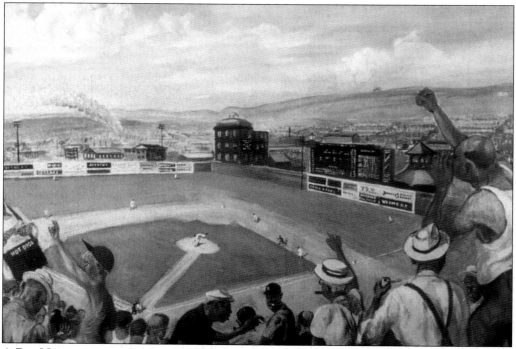

A Big Night at the Ballpark. This painting by Jim Holton likely drew its inspiration from the previous photograph. The artist livened up the scene a bit with his whimsical depictions of early Reading baseball fans. (HSBC files.)

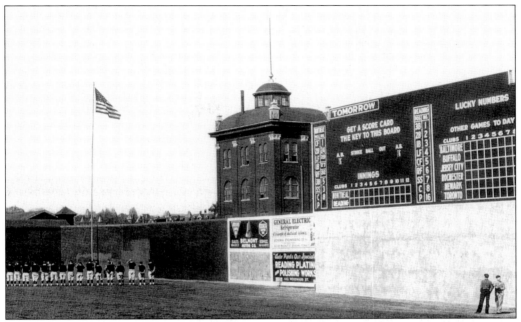

GAME TIME. One of the buildings of Deppen's Brewery towers over the scoreboard at Lauer's Park in the 1920s. The cupola-topped structure still stands on North Third Street, near Buttonwood Street. (HSBC files, photograph by Paul L. Glaser.)

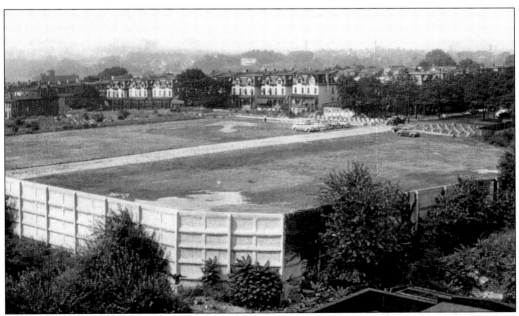

BETWEEN THE BALLPARK AND THE SCHOOL. The remains of the Lauer's Park baseball diamond and its outfield walls are ghostly images in this early-1950s view of the grounds. For a while, the grounds on which the stadium once stood were used as a city parking lot. In the 1960s, those grounds gave way for the Lauer's Park Elementary School. (HSBC files.)

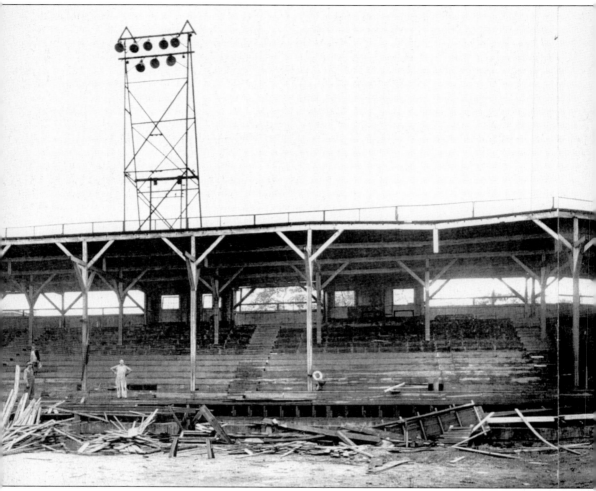

THE BEGINNING OF THE END. Lauer's Park, doomed by its small seating capacity, lack of adequate parking, and squabbles over leasing agreements, fell to the wrecker's ball after its

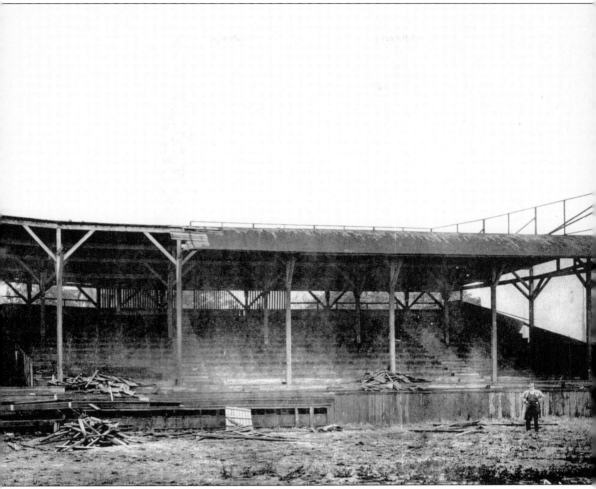

last tenant, an ill-fated Inter-State League Brooklyn Dodgers affiliate, played there in 1941. Condemned as unsafe, it was dismantled by the city in 1943. (HSBC files.)

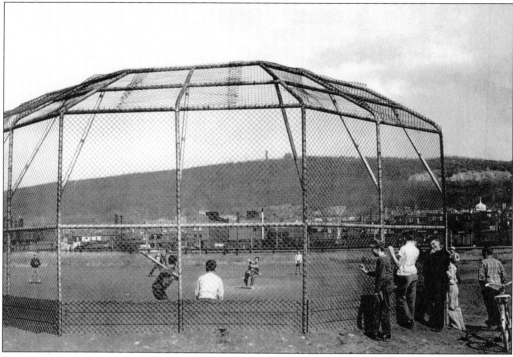

DOWN IN THE HOLLOW. Many Reading residents will remember playing pickup ball at the Hollow, this old city baseball field at Sixth and Oley Streets. Note the Reading Railroad yards just beyond the outfield and the fire tower and Tower Hotel atop Mount Penn. (HSBC files.)

PENDORA PARK. The Lindbergh Viaduct towers over the action on the baseball field at Pendora Park in East Reading. (HSBC files.)

Five

"PLAY BALL"
AT THE NEW STADIUM

On May 23, 1951, on an unfamiliar Asian peninsula called Korea, Americans were fighting and dying. On the home front, in Reading, the circus was in town. Up at Dorney Park, Clarabelle, the clown from the *Howdy Doody Show,* was performing. In downtown Reading, $14.95 would buy you a good pair of shoes at Wetherhold and Metzger. A new suit at Croll and Keck would set you back $45. Pomeroy's was celebrating with a diamond jubilee sale, and a new porcelain ringer washer was marked down to $89.95. Food Fair and Acme supermarkets were battling it out for customers, but down at B & J Saylor's, a beef roast could be had for 78¢ a pound.

In the movie houses of the city, *Apache Drums* was at the Astor, and *On the Riviera,* starring Sammy Kaye, was at the Embassy. It was a big day for the Reading Municipal Airport, which was named Gen. Carl A. Spaatz Field in honor of the Boyertown-born war hero. In sports, the track-and-field team of Albright College was in the thick of competition, coached by a gentleman named Gene Shirk, who later become the city's mayor. The "Reading Dutchman," racing star Tommy Hinnershitz, was getting ready for another banner year behind the wheel as the Reading Fairgrounds dirt track awaited opening day.

It was a good spring for residents of Berks County in the big leagues. Vic Wertz was hitting .300 for the Tigers, Randy Gumpert was 2-0 for the White Sox, and Carl Furillo, the Reading Rifle, had a nine-game hitting streak going. Furillo's Dodgers were atop the National League standings while their crosstown rivals, the Yankees, led the American League.

The Philadelphia Phillies (last year's "Whiz Kids") were in sixth place out of eight, four and a half games out of first. However, the season was young and they were doing a lot better than the other Philly team, the Athletics, who were already in seventh place, 13 games out.

In Reading, at what was known as Cathedral Heights—inside what was variously known as Municipal or Memorial Stadium or the War Memorial—the lights, the 275,000 watts of Mazdas, were to be switched on and the very first official game on this field was to be played. A team from Quakertown came to town and face Reeser's All-Stars on that date—May 23, 1951—but, nature won. Rain forced postponement of the game until Monday, May 28—the day baseball was finally inaugurated at Reading's new stadium.

In that model minor-league baseball shrine, guys named "Whitey" and "Lefty" and "Clemens" brought baseball to Reading's field of dreams. Their dreams were to play baseball, not much more. They were not professionals—they were semiprofessionals, former minor-leaguers, a couple of college kids, American Legion players, and just some guys who played good sandlot ball. They came to play the game.

Reading, of course, had already been a hotbed of minor-league ball, on other fields and in other stadiums. No one in the misty May dusk in 1951—not one of the 824 fans who watched

67

that first game at Municipal Memorial Stadium—could ever have dreamed of what has transpired there since then.

That "Whitey" who came to play that night was not named Ford; he was Whitey Mellor, the first man to take a pitch at "the ballyard." Mellor was the captain of the visiting Norristown Blocks, a team sponsored by Block Brothers' Furniture Store. "Lefty" was not Gomez, not Grove, not Carlton, but Lefty Reeser, a Tuckerton restaurant owner and sponsor of the Reading team. Clemens was "Scoop" Clemens, the future Muhlenberg High athletic director. He was also the umpire who, under the stadium lights made history when he shouted, "Play ball!"

PLAY BALL (AGAIN)! The return of minor-league baseball in Reading was made official when Mayor James B. Bamford threw out the ceremonial first pitch at the new Municipal Memorial Stadium in 1952. The celebration did not come without challenges. The Reading-Berks Chamber of Commerce, Berks Branch of the Pennsylvania Economy League, League of Women Voters, Real Estate Board, and the Retail Merchants Association were all against the erection of the stadium. They felt it was more important for the city to build a new garbage plant instead. Luckily for baseball fans, the city prevailed. Even then, however, things did not go quite as the council may have liked. In 1950, the federal government ordered a ration of steel during the Korean War. Reading applied for and received special permission to purchase the steel needed to continue construction of the stadium. The stadium operated some $16,800 in the red during its first year. Income from 1952 included $5,000 rent from the Reading Indians, $250 rent from a company that sold Christmas trees on the parking lot, and $389.06 from concessions. Wages, equipment, and utilities, however, sent initial costs soaring well over revenues. (*Reading Eagle* files.)

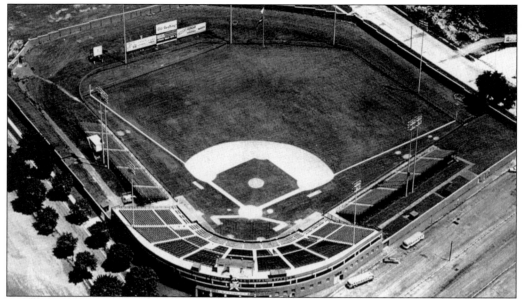

CATHEDRAL HEIGHTS. Known first as the Shepp Farm, the land upon which FirstEnergy Stadium is situated was bought by the Reading Lodge of Perfection, Ancient Accepted Scottish Rite of Free Masons in 1926 with the intent of building a Scottish Rite Cathedral on the site. The land thus became known as Cathedral Heights. In 1945, the Masons sold 27 acres of the land to the city for $64,400 and abandoned the cathedral plans. This view, probably taken in the early 1960s, shows a stark, simple, but functional stadium. Note the Reading Indians logo above the main gate. (Reading Stadium Commission.)

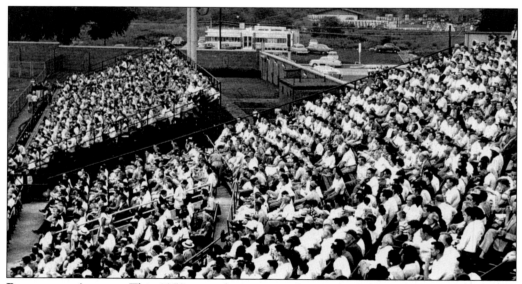

READY FOR ACTION. This 1952 view shows no roof, no right-field food court, and no pool area at Municipal Memorial Stadium, but there is a big crowd. Note the Glidden Paints test field in the distance to the upper right. The Reading ballpark was the only one in the Eastern League without a roof. When it opened, it included 888 box seats, 1,236 reserved seats, 1,632 grandstand seats, and about 4,200 bleacher seats. (Reading Stadium Commission.)

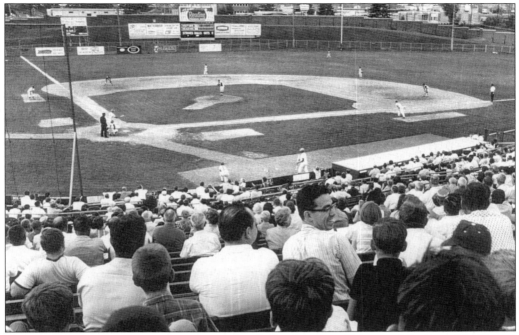

DIAMOND DAY. From the very beginning of baseball at Municipal Memorial Stadium (FirstEnergy Stadium), one thing has remained constant: the diamond itself. Current fans will note subtle differences in the field layout, but very substantive differences in the seating arrangement in the stands. The fans in this early photograph of Municipal Stadium are not under a roof and are sitting on sturdy, wooden pew-type benches. (Reading Stadium Commission.)

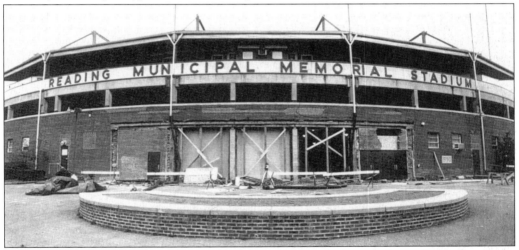

CONSTANT UPGRADE. Consistently ranked among the very best minor-league baseball stadiums in the nation, Reading's FirstEnergy Stadium has undergone many modifications and expansions within its storied walls. Each of those changes, however, retained the intimate "feel" of the ballpark. One proposed change to the stadium was never realized. After the assassination of Pres. John F. Kennedy in 1963, certain city council members suggested the stadium name be changed to John F. Kennedy Stadium. Mayor John C. Kubacki led the successful opposition, stating, "I am sure the late president himself would oppose naming after himself a stadium which was dedicated to the war veterans." (Reading Stadium Commission.)

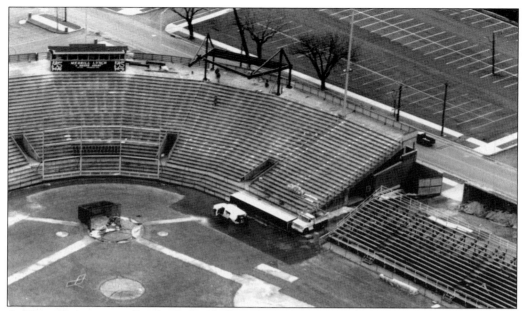

A NEW BEGINNING. Reading's baseball stadium cost about $600,000 to build, but since the Reading Phillies came to town, it has undergone more than $4 million in renovations, expansions, and restoration. In this picture, the very first steps toward building a roof over the grandstand and expanding the press box are noticeable in the steel framework on the upper-level concourse. Note that the grandstand is stripped of its seats. (Reading Phillies files.)

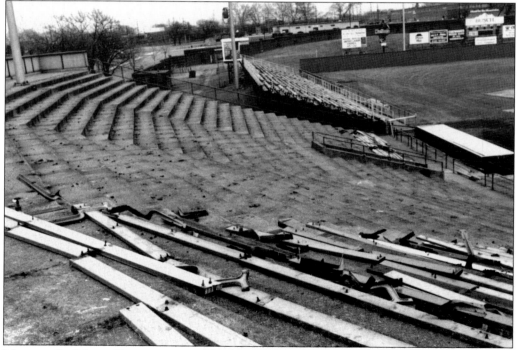

MAKING IT MORE COMFORTABLE. The last of the old wooden benches are removed from the stadium grandstand to make room for plastic seats with backs and cup holders. (Reading Phillies files.)

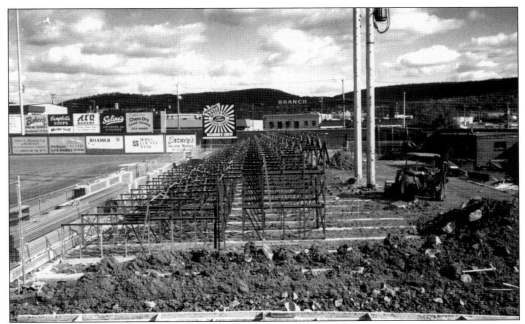

THE RIGHT-FIELD GRANDSTAND EXPANDS. At one time, Reading's stadium was used (overused, many said) for high-school football games. The right-field bleachers were actually moved into right field and served as a grandstand for the football field. The goalposts were situated just south of the left-field wall and just north of the baseball backstop. This picture shows the construction of permanent stands along right field. (Reading Phillies files.)

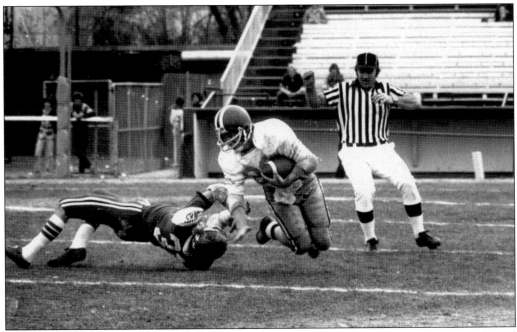

FOOTBALL IN A BASEBALL BOOK? This is the home team dugout and a portion of the grandstand of FirstEnergy Stadium (then Municipal Memorial Stadium, in the 1970s) when it was used for high-school football games. (Photograph by the author.)

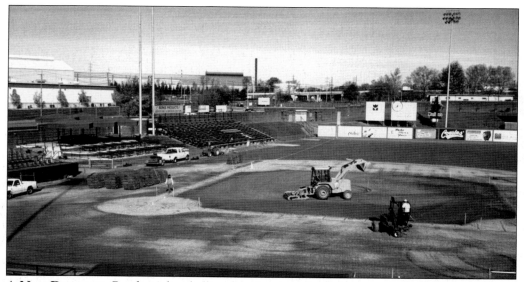

A NEW DIAMOND. Reading's baseball stadium has been hailed as one of the finest in the minor leagues. The playing field is approximately three acres of grass, dirt, and stone. The infield grass is a mixture of Kentucky bluegrass and perennial ryegrass. The outfield is all Kentucky bluegrass. The infield skinned area is a mixture of 65 percent sand, 20 percent silt, and 15 percent clay. The warning track is made up of limestone screenings. The entire field is graded so that excess rainfall will run off to the warning track and into drains. Head groundskeeper Dan "Dirt" Douglas is a three-time winner of the Eastern League Groundskeeper of the Year award. In 2002, he was honored with the Harry C. Gill Award, a founders award from the Sports Turf Managers Association. (Reading Phillies files.)

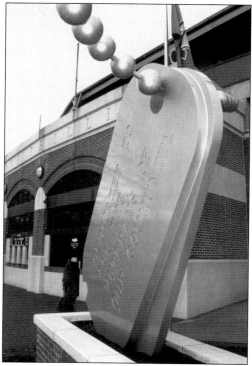

NEVER FORGETTING. Despite the massive changes made to the facility, and no matter that naming rights were sold in 1999, Reading Municipal Memorial Stadium, named in honor of Reading area veterans, remains dedicated to that original sentiment. On March 25, 2000, the stadium (then GPU Stadium) was rededicated to veterans in a ceremony that marked the unveiling of this monument, which stands near the main gate. The inscription on the dog tags reads, "Dedicated to the Veterans of Our Community." (Photograph by the author.)

THE DIAMOND SPARKLES. There is no end to the praises given to FirstEnergy Stadium by true baseball fans and families looking for a fun and economical night out. The stadium now includes a pool pavilion in right field, a deck-picnic area in left field, a "Power Alley Pub" in left center field, a picnic pavilion just off third base, a deck party buffet, a food court behind the right-field stands, and a 46-foot-tall, 60-foot-wide video scoreboard that was the first of its kind in the minor leagues. To the right of the main scoreboard is a pitch speed indicator. An auxiliary scoreboard is located above the right-field grandstand near first base. The board faces left field to provide fans on the deck with the score, count, outs, inning, and time. The concourse at FirstEnergy Stadium features several color televisions mounted above concession stands, and each of the 31 picnic tables in the pool pavilion has its own color television with full cable access. For the 2003 season, an indoor pub was built beneath the right-field fence. (Photograph by Ralph L. Trout.)

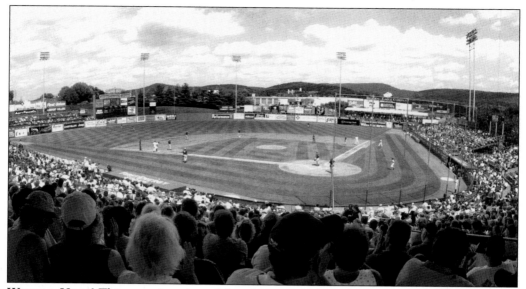

WHAT A VIEW! This sweeping view of the playing field from the top of the grandstand shows the great line-of-sight from any seat in the house. In left center field is the scoreboard that was installed in 1998. The board's premier feature is its 1-foot-high, 15-foot-wide Prostar video that employs 110,592 individual LED lamps. On the bottom of the scoreboard is a 35-foot-wide Sunspot message center display made up of 2,560 25-watt bulbs. Between the video display and message center is the game score, balls, strikes, outs, runs, hits, and errors. (Photograph by Ralph L. Trout.)

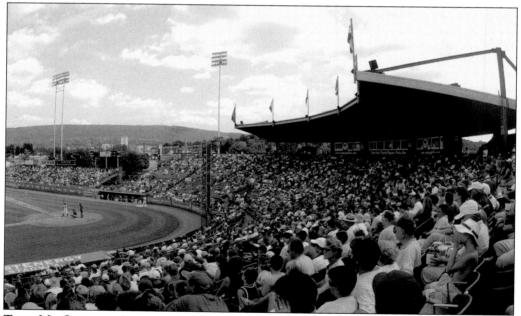

TAKE ME OUT. . . . Large crowds have become the norm at FirstEnergy Stadium. The most people ever to attend a Phillies game were those at the May 4, 2001 game against Altoona when 9,792 fans packed the place. Reading is also the Eastern League's all-time attendance leader and the only Eastern League franchise to draw more than seven million fans in league history. (Photograph by Ralph L. Trout.)

Six

THE INDIANS
COME TO TOWN

Another baseball great played a major role in the minor-league fortunes of Reading. After the Reading stadium project was confirmed in the late 1940s, the word got out throughout the baseball community and the general manager of the Cleveland Indians, Hank Greenberg, sat up and noticed. He was dismayed over the failing Artillery Park stadium conditions and dropping attendance figures at the Tribe's Eastern League link in Wilkes-Barre and considered Reading as a viable replacement for the troubled franchise. He told farm system officials to keep an eye on the Reading situation.

The Indians' general manager had attended the "Oldtimers" banquet in January 1950. During his visit, he had a look at the construction at Cathedral Heights and was impressed with the progress being made on the new stadium. On November 2, 1951, Greenberg's seed bore fruit as the Indians' franchise was shifted from the shores of the Susquehanna to the shores of the Schuylkill. Eddie Stumpf (business director of the Cleveland farm system), Michael J. McNally (president of the Indians-owned Wilkes-Barre club), and Stewart "Spike" Moyer (administrator of the stadium) confirmed the deal. Thomas S. Richardson, president of the Eastern League, notified all that the league's owners had also approved the move.

It was bitter irony for Wilkes-Barre. Their team had, just two months prior, won its second consecutive Eastern League pennant. Reading joined Scranton and Williamsport, Pennsylvania; Binghamton, Elmira, Schenectady, and Albany, New York; and Hartford, Connecticut in the eight-team loop. In one sense, baseball had come full circle. Reading's old International League team moved to Albany in 1932. Twenty years later, Albany was back in the then-Class A Eastern League with Reading.

When the transition was finalized, one of the two vice presidents of the Reading Indians team was Hank Greenberg. If the opening of Municipal Memorial Stadium indeed marked the beginning of the "modern era" of minor-league ball in Reading, that era itself can be subdivided into three—even four or five—periods.

From 1952 through 1961, Reading fans enjoyed a cordial relationship with the Indians, but the baseball stadium became a political football. Cleveland's front office became more demanding on the issue of stadium rental fees (the Tribe paid a maximum of $6,200 a year for rental but suggested it pay $1 a year), and conditions deteriorated to the point that the Indians pulled up stakes after the 1961 season, when the team finished 59-81, 26.5 games out of first place. The franchise was transferred to Charleston, West Virginia. It was not the best of times for minor-league baseball in Baseballtown. As the Cleveland announcement came too late for supporters to attract another team for the opening of the next season, the summer of 1962 came and went without organized ball at the ballyard.

A glimmer of hope came in May 1962, when organizers of a revived Inter-State League contacted Mayor John C. Kubacki and expressed hopes that the city could promote and support a team in the league. Local officials considered the proposal, but the 1962 baseball season proceeded without a Reading team in that, or any other, league.

Well-traveled team owner Joe Buzas moved a Red Sox franchise from York to Reading for the 1963 and 1964 seasons. That first year of the ill-fated Reading Red Sox was also the first year of the Class AA designation for the Eastern League. Buzas, who previous to York had operated teams in Allentown and Johnstown, endured a stormy relationship with city officials during his stint at the stadium. The 1963 season ended with the Reading Red Sox firmly entrenched in the Eastern League cellar.

In 1964, Reading manager Eddie Popowski and a lineup that included Berks' own Dick Gernert brought respectability back to the field performance with an 80-60 mark good enough for second place. Still, attendance was eroding. Finally, on December 30, 1964, Buzas pulled the plug and packed his team off to Pittsfield, Massachusetts. Reading was without minor-league baseball once again—but not for long.

Less than a month later, the Cleveland Indians returned with the placement of a team at the stadium. The parent club transferred the franchise from Charleston back to Reading. A funny thing happened on the road to franchise stability. The Indians' second time at bat in Reading resulted in a strikeout after the first year. Again in 1966, Reading failed to field a minor-league baseball team.

That all changed with a monumental announcement on October 27, 1966. That was the day the baseball fans of Reading learned that the Philadelphia Phillies would be stepping to the plate.

THE INDIANS COME TO TOWN. Reading Municipal Memorial Stadium was completed in 1951, but there was no agreement with any major-league team to host a farm club in Reading. The Reading Recreation Board and the Cleveland Baseball Company came to terms just in time for the 1952 season, when minor-league baseball returned to the city in the form of Chief Wahoo, the grinning mascot of the Tribe. (Reading Phillies files.)

BACK IN BUSINESS. This was the team that brought organized baseball back to Reading after a 10-season absence. The 1952 Indians were managed by Kerby Farrell, who had a short career in the majors as a first baseman and pitcher for the Boston Braves and Chicago White Sox from 1943 to 1945. Farrell went on to manage the Cleveland Indians to a 76-77 record in his only stint there in 1957. From left to right are the following team members: (front row) Prentice, Pawloski, Dargie, Catron, Farrell (manager), Ohlinger, Fuller, and Vargas; (back row) Milankovich, Lutz, Lawrence, Peters, Meyer, Murray, Rowell, Altobelli, Tomanek, Rodemoyer, and Stockhausen. (HSBC files.)

"Hey, Get Your Scorecard!" The cover of an early Reading Indians scorecard (note the price at 10¢) appears to present repetitive caricatures of Chief Wahoo around the word *Indians*. Look closely at the facial expressions of the chief. Also note the cost for travel insurance in the American Casualty Company advertisement. (HSBC files.)

10¢

INDI NS →

OFFICIAL
SOUVENIR
PROGRAM

Going Places?

Vacation—business—convention—weekend? Don't take a trip unless you have a TRIP ACCIDENT INSURANCE. Accidents are covered 24 hours a day anywhere in the world. $5000 to $50,000 Accidental Death & Dismemberment benefit and $500 to $5000 Accident Medical Expense benefit. Policies issued for any period from 1 day to 6 months. A $5000/$500 policy costs only $2.00 for 7 days. Phone your American Casualty agent and ask for a TRIP-MASTER Policy. Baggage Insurance can be included.

American Casualty Company Reading, Pa.

STILL A DIME. The logo was updated a bit, but the price of a later Reading Indians scorecard (and the travel insurance) remained the same. (Reading Phillies files.)

Hotel Headquarters—1953

EASTERN LEAGUE

	At Albany	At Binghamton	At Elmira	At Reading	At Scranton	At Schenectady	At Wilkes-Barre	At Williamsport
Albany		Arlington	Langwell	Lincoln	Jermyn		Sterling	Lycoming
Binghamton	Ten Eyck		Langwell	Berkshire	Jermyn	Ten Eyck (Al.)	Sterling	Lycoming
Elmira	Ten Eyck	Arlington		Berkshire	Casey	Ten Eyck (Al.)	Sterling	Lycoming
Reading	Ten Eyck	Arlington	Langwell		Jermyn	Ten Eyck (Al.)	Sterling	Lycoming
Scranton	Ten Eyck	Arlington	Langwell	Berkshire		Ten Eyck (Al.)		Lycoming
Schenectady		Arlington	Langwell	Berkshire	Jermyn		Sterling	Lycoming
Wilkes-Barre	Ten Eyck	Arlington	Langwell	Berkshire		Ten Eyck (Al.)		Lycoming
Williamsport	Ten Eyck	Arlington	Langwell	Berkshire	Casey	Ten Eyck (Al.)	Sterling	

MILEAGE TABLE

Albany to	Binghamton ... 140
	Elmira 200
	Reading 227
	Schenectady ... 15
	Scranton 188
	Wilkes-Barre .. 206
	Williamsport ... 267
Binghamton to	Albany 140
	Elmira 59
	Reading 156
	Schenectady ... 129
	Scranton 63
	Wilkes-Barre .. 80
	Williamsport .. 127
Elmira to	Albany 200
	Binghamton ... 59
	Reading 187

Wilkes-Barre to	Albany 206
	Binghamton ... 80
	Elmira 91
	Reading 92
	Schenectady ... 209
	Scranton 18
	Williamsport ... 66
Scranton to	Albany 188
	Binghamton ... 63
	Elmira 103
	Reading 101
	Schenectady ... 193
	Wilkes-Barre .. 18
	Williamsport ... 84
Reading to	Albany 227
	Binghamton ... 156
	Elmira 187

Schenectady to	Albany 15
	Binghamton ... 129
	Elmira 188
	Reading 187
	Scranton 193
	Wilkes-Barre .. 206
	Williamsport ... 240
Williamsport to	Albany 267
	Binghamton ... 127
	Elmira 74
	Reading 111
	Schenectady ... 240
	Scranton 84
	Wilkes-Barre .. 66

These mileages were compiled according to the best routes, which in some case...

THE EASTERN LEAGUE, 1953. Included in the Reading Indians' scorecard was this guide to Eastern League cities, mileage between them, and hotels used by teams in the various cities. (HSBC files.)

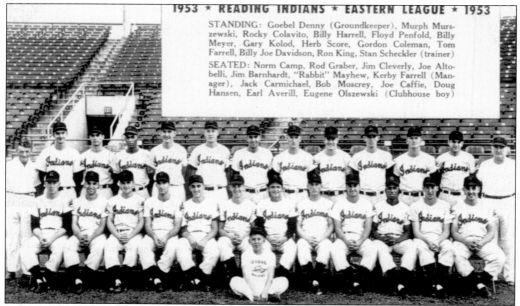

1953 ★ READING INDIANS ★ EASTERN LEAGUE ★ 1953

STANDING: Goebel Denny (Groundkeeper), Murph Murszewski, Rocky Colavito, Billy Harrell, Floyd Penfold, Billy Meyer, Gary Kolod, Herb Score, Gordon Coleman, Tom Farrell, Billy Joe Davidson, Ron King, Stan Scheckler (trainer)

SEATED: Norm Camp, Rod Graber, Jim Cleverly, Joe Altobelli, Jim Barnhardt, "Rabbit" Mayhew, Kerby Farrell (Manager), Jack Carmichael, Bob Moscrey, Joe Caffie, Doug Hansen, Earl Averill, Eugene Olszewski (Clubhouse boy)

DOWN ON THE FARM. Before they made it big in the majors, players such as Herb Score, Earl Averill, and, of course, Rocky Colavito served their time with the Reading Indians, as witnessed in this 1953 team photograph. This team, which set an Eastern League record for wins (101) and several franchise records, is one of the 2003 Reading Baseball Hall of Fame inductees. (HSBC files.)

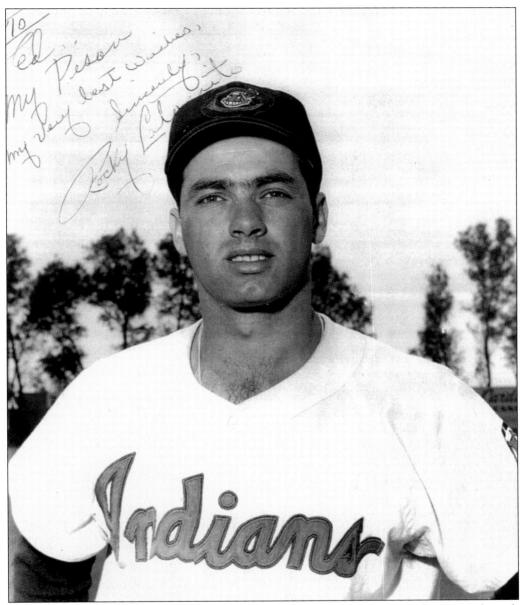

"ROCKY" IN READING. Rocco Domenico Colavito passed from his home in the Bronx through Reading and on to an illustrious major-league career with the Cleveland Indians (1955–1959), Detroit Tigers (1960–1963), Kansas City Athletics (1964), Cleveland Indians (1965–1967), Chicago White Sox (1967), Los Angeles Dodgers (1968), and New York Yankees (1968). He finished his big-league career with 374 lifetime home runs. "The Rock" also had many highlights during his years in the majors. On June 10, 1959, he hit four consecutive home runs in one game. In 1959, he tied for the American League home run title with 42. He was also selected for the All-Star roster in 1959, 1961, 1962, 1964, 1965, and 1966. In 1968, he traded his outfielder's glove for the resin bag and, on August 25, pitched two and two-thirds innings in relief for the Yankees, gave up only one hit, and was credited with the victory. Colavito must have taken a liking to the Reading area during his playing time, because he has lived in the area ever since. In 1958, he was voted Berks County's Outstanding Athlete of the Year. (Dr. Flannery files.)

CAN I HAVE YOUR AUTOGRAPH? Then as now, autograph collecting was a big deal at the minor-league level, where players are accessible and usually quite willing to sign. The barrel of the bat of this Eastern League directory from 1953 was autographed by up-and-coming star Rocky Colavito. (HSBC files.)

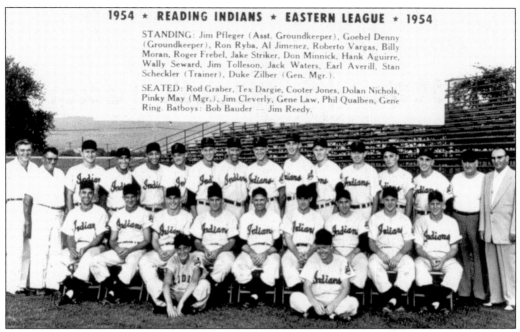

1954 ★ READING INDIANS ★ EASTERN LEAGUE ★ 1954

STANDING: Jim Pfleger (Asst. Groundkeeper), Goebel Denny (Groundkeeper), Ron Ryba, Al Jimenez, Roberto Vargas, Billy Moran, Roger Frebel, Jake Striker, Don Minnick, Hank Aguirre, Wally Seward, Jim Tolleson, Jack Waters, Earl Averill, Stan Scheckler (Trainer), Duke Zilber (Gen. Mgr.).

SEATED: Rod Graber, Tex Dargie, Cooter Jones, Dolan Nichols, Pinky May (Mgr.), Jim Cleverly, Gene Law, Phil Qualben, Gene Ring. Batboys: Bob Bauder — Jim Reedy.

WHEN "COOTER" CAME TO TOWN. Several future big-leaguers are shown in this 1954 team photograph of the Reading Indians, but one standout name is that of Paul "Cooter" Jones. Jones played for the Indians through 1959 and stayed on in Reading to serve as Reading High School's baseball coach from 1972 to 1996. In 1983, his Red Knights won the Pennsylvania State High School Baseball Championship. (HSBC files.)

WHEN "COOTER" WENT ON THE ROAD. Pictured is the old ballpark in Binghamton, New York, where the Triplets once met the Reading Indians in the 1950s. Here, with Stan Turner at first, the Indians' Cooter Jones gets ready to take his cuts. (Paul Jones collection.)

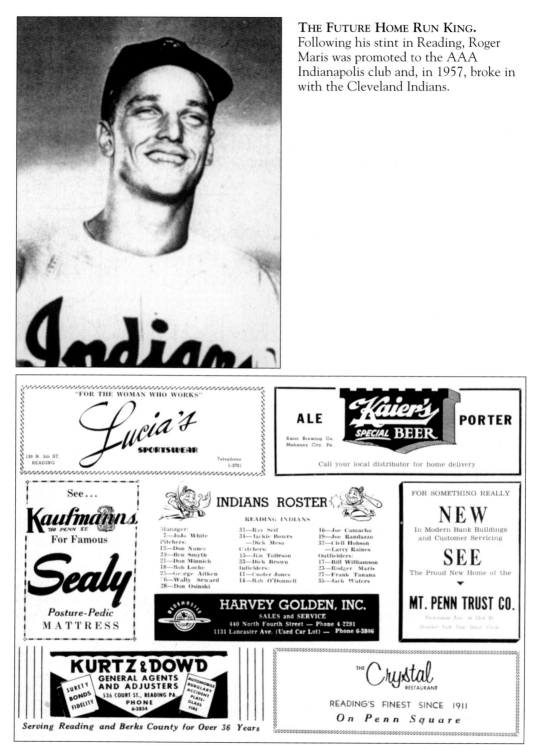

THE FUTURE HOME RUN KING.
Following his stint in Reading, Roger Maris was promoted to the AAA Indianapolis club and, in 1957, broke in with the Cleveland Indians.

THE NAME GAME. Look closely at this roster insert for the 1955 Reading Indians. The names of some of the businesses that supported the minor-league organization then have been changed or forgotten, except No. 23, outfielder "Rodger" Maris. (HSBC files.)

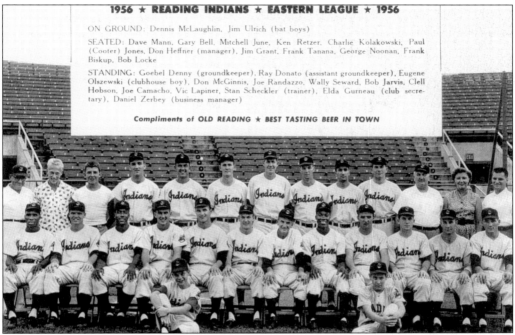

MANN AND MUDCAT. Two notable players were on the Reading Indians' 1956 roster: Dave Mann and the legendary Jim "Mudcat" Grant. In 1965, Grant joined the elite 20-wins club with the Cleveland Indians. (HSBC files.)

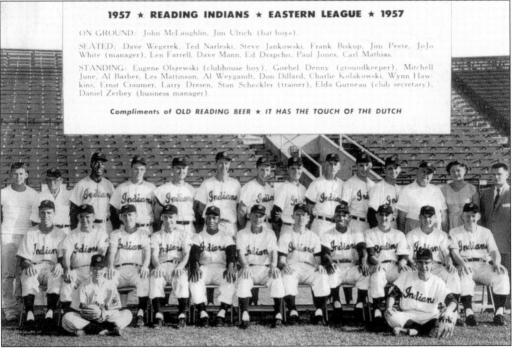

THE READING 1957 INDIANS. Among the notable names with local ties on this squad, which posted a 74-66 record and won the Eastern League championship, are Paul "Cooter" Jones, Carl Mathias, and Charlie Kolakowski. (Paul Jones collection.)

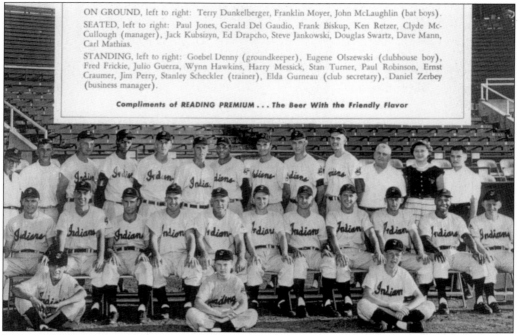

ON GROUND, left to right: Terry Dunkelberger, Franklin Moyer, John McLaughlin (bat boys).

SEATED, left to right: Paul Jones, Gerald Del Gaudio, Frank Biskup, Ken Retzer, Clyde Mc-Cullough (manager), Jack Kubsizyn, Ed Drapcho, Steve Jankowski, Douglas Swartz, Dave Mann, Carl Mathias.

STANDING, left to right: Goebel Denny (groundkeeper), Eugene Olszewski (clubhouse boy), Fred Frickie, Julio Guerra, Wynn Hawkins, Harry Messick, Stan Turner, Paul Robinson, Ernst Craumer, Jim Perry, Stanley Scheckler (trainer), Elda Gurneau (club secretary), Daniel Zerbey (business manager).

Compliments of READING PREMIUM . . . The Beer With the Friendly Flavor

THE 1958 READING INDIANS. Among those on this year's team was Jim Perry (standing, fourth from right), who went up to the Cleveland Indians in 1959 and then to the Minnesota Twins, where in 1969 he posted 20 wins and in 1970 registered 24 wins on the way to a 17-year major-league career. Perry was inducted into the Reading Baseball Hall of Fame in 1998. (Paul Jones collection.)

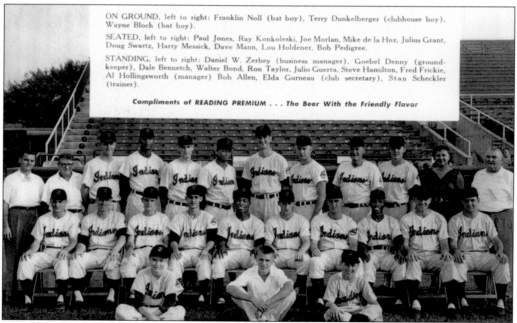

ON GROUND, left to right: Franklin Noll (bat boy), Terry Dunkelberger (clubhouse boy), Wayne Bloch (bat boy).

SEATED, left to right: Paul Jones, Ray Konkoleski, Joe Morlan, Mike de la Hoz, Julius Grant, Doug Swartz, Harry Messick, Dave Mann, Lou Holdener, Bob Pedigree.

STANDING, left to right: Daniel W. Zerbey (business manager), Goebel Denny (ground-keeper), Dale Bennetch, Walter Bond, Ron Taylor, Julio Guerra, Steve Hamilton, Fred Frickie, Al Hollingsworth (manager) Bob Allen, Elda Gurneau (club secretary), Stan Scheckler (trainer).

Compliments of READING PREMIUM . . . The Beer With the Friendly Flavor

THE 1959 READING INDIANS. Al Hollingsworth, who had an 11-year major-league career with six different teams (including 1938 and 1939 with the Philadelphia Phillies), was manager of this team that posted a 71-69 record. (Paul Jones collection.)

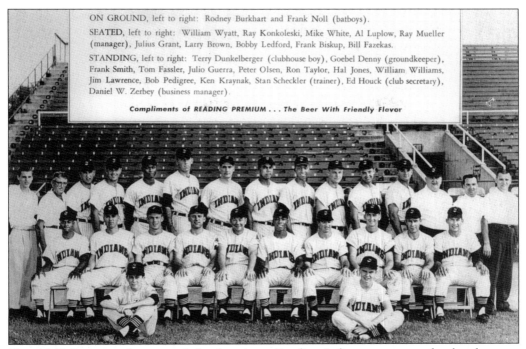

ON GROUND, left to right: Rodney Burkhart and Frank Noll (batboys).

SEATED, left to right: William Wyatt, Ray Konkoleski, Mike White, Al Luplow, Ray Mueller (manager), Julius Grant, Larry Brown, Bobby Ledford, Frank Biskup, Bill Fazekas.

STANDING, left to right: Terry Dunkelberger (clubhouse boy), Goebel Denny (groundkeeper), Frank Smith, Tom Fassler, Julio Guerra, Peter Olsen, Ron Taylor, Hal Jones, William Williams, Jim Lawrence, Bob Pedigree, Ken Kraynak, Stan Scheckler (trainer), Ed Houck (club secretary), Daniel W. Zerbey (business manager).

Compliments of READING PREMIUM . . . The Beer With Friendly Flavor

THE 1960 READING INDIANS. A fan favorite at Reading Indians games was the day the team photographs were given out courtesy of the Reading Brewing Company.

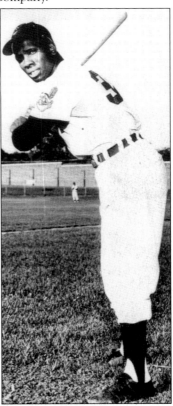

DAVE MANN. This fleet-footed slugger was a crowd favorite who led the Eastern League in stolen bases in 1956 and for the three seasons that followed. In 1958, Mann set a Reading franchise record with 66 steals. That same year, he hit .289, scored a league-leading 110 runs, and was named the Eastern League MVP. He also led the Eastern League in triples in three seasons. In his four years in Reading, he had a batting average of .301 and stole a total of 218 bases. He was elected to the Reading Baseball Hall of Fame in 1999. (Reading Phillies files.)

THE BOYS OF SUMMER. Wearing their Reading Indians uniforms proudly is this quintet of players who provided thrills for local fans in the late 1950s. From left to right are Carl Mathias, Jim Perry, Wynn Hawkins, Ed Drapcho, and Paul Robinson. (Reading Phillies files.)

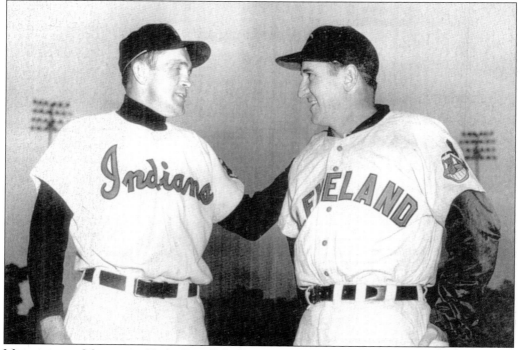

MANAGER TO MANAGER. Kerby Farrell (left), manager of the 1953 Reading Indians (who won the Eastern League championship that year), confers with Al Lopez, field boss of the parent Cleveland club. (Dr. Flannery files.)

PROGRAMS—10¢! Good old Chief Wahoo grins his trademark grin in this Reading Indians scorecard cover. Note that the sponsor of the page is the long-defunct Food Fair grocery store chain. (HSBC files.)

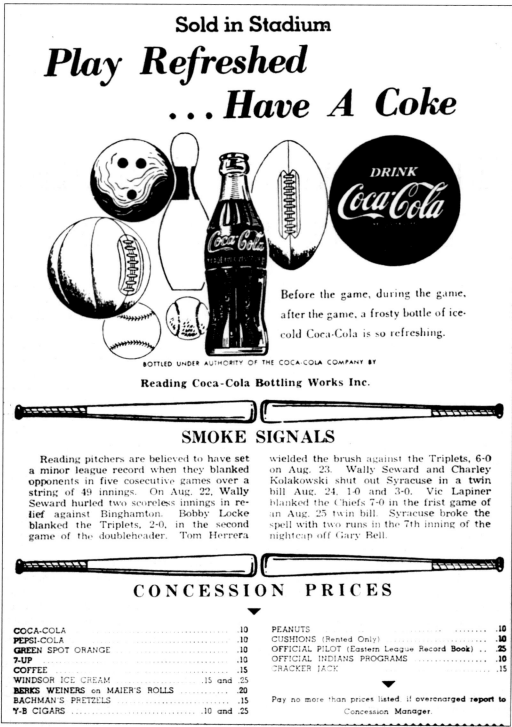

Sold in Stadium
Play Refreshed
...Have A Coke

DRINK Coca-Cola

Before the game, during the game, after the game, a frosty bottle of ice-cold Coca-Cola is so refreshing.

BOTTLED UNDER AUTHORITY OF THE COCA-COLA COMPANY BY

Reading Coca-Cola Bottling Works Inc.

SMOKE SIGNALS

Reading pitchers are believed to have set a minor league record when they blanked opponents in five cosecutive games over a string of 49 innings. On Aug. 22, Wally Seward hurled two scoreless innings in relief against Binghamton. Bobby Locke blanked the Triplets, 2-0, in the second game of the doubleheader. Tom Herrera wielded the brush against the Triplets, 6-0 on Aug. 23. Wally Seward and Charley Kolakowski shut out Syracuse in a twin bill Aug. 24, 1-0 and 3-0. Vic Lapiner blanked the Chiefs 7-0 in the frist game of an Aug. 25 twin bill. Syracuse broke the spell with two runs in the 7th inning of the nightcap off Gary Bell.

CONCESSION PRICES

▼

COCA-COLA		.10
PEPSI-COLA		.10
GREEN SPOT ORANGE		.10
7-UP		.10
COFFEE		.15
WINDSOR ICE CREAM		.15 and .25
BERKS WEINERS on MAIER'S ROLLS		.20
BACHMAN'S PRETZELS		.15
Y-B CIGARS		.10 and .25

PEANUTS		.10
CUSHIONS (Rented Only)		.10
OFFICIAL PILOT (Eastern League Record Book)		.25
OFFICIAL INDIANS PROGRAMS		.10
CRACKER JACK		.15

▼

Pay no more than prices listed, if overcharged report to Concession Manager.

HOT DOGS—20¢! From cigars to cushion rentals, the concession prices listed in this 1955 Reading Indians program book are interesting, as is the special note at the end of the price list. (HSBC files.)

Seven

THE READING PHILLIES: THE FIRST 20 YEARS

Three days before Halloween in 1966, baseball fans in Reading were treated to an announcement that baseball would return to town after five tricky years of on-again, off-again action at Municipal Memorial Stadium. This time, it would not be an organization from Cleveland or Boston, but a club that was fewer than 60 miles from Reading.

John J. Quinn, general manager of the Philadelphia Phillies, assured Reading Stadium Commission members that the Phillies would bring a team to Reading if all the legal i's were dotted and the playing field's t's were crossed in time for the start of the 1967 season. The city, the stadium staff, and the Phillies' front office were all poised to ensure that all technicalities would indeed be tackled after the final high-school football game of the 1966 season was played out at the stadium. Quinn and Phillies farm director Paul Owens were confident the arrangement would be a good fit. "We hope to have a good relationship with your city for a number of years," Quinn told stadium commission members. He could never have dreamed that it would become one of the longest relationships ever in major- and minor-league baseball.

With Bob Quinn, John's son, as general manager, the Reading Phillies took their bow on opening day in 1967. A record crowd of 5,857 watched on April 22 as the home team beat York 9-3 in the first Reading Phillies game ever. Reading fans did not wait long to realize that the Phillies considered their town to be a serious proving ground for the stars of the future. In only the second year of their existence, the Reading Phillies copped their first Eastern League championship. A key player on that team was a kid named Larry Bowa.

With the Philadelphia organization tending to player development—and tending it well— the city, its stadium commissioners, and Reading Phillies owners concentrated on improving the showplace and the show. It was not always easy. Through the 1970s, man and nature often wreaked havoc at the stadium. Vandals damaged, destroyed, or removed items there on several occasions. Sinkholes were discovered on the playing field. A truck crashed into one of the walls. The most devastating event at the stadium was also the most devastating event in Reading history: Tropical Storm Agnes in June 1972.

As floods ravaged Reading and other communities on the banks of the Schuylkill River, the storm left the stadium's field inundated. There was six feet of water in the dugouts. The electrical system was ruined. Some $40,000 of Phillies team equipment was destroyed. Thousands of dollars worth of fireworks that were stored there in anticipation of the Fourth of July celebration were waterlogged and worthless. In all, damage estimates topped the $100,000 mark. Phillies general manager Jim Bronson told the local media that he watched the floodwaters rise to the point that he could either flee his office or go down with the ship. He chose the first option.

Another irony came to a head in July 1973, when the state approved the sale of beer at the stadium. On opening day in 1974, the taps were tugged and the beer flowed. This occurred in a city once known for its breweries and for an attraction once fully supported by those breweries (look at the ads in the old Reading Indians programs). What's more, Reading's first minor-league stadium, Lauer's Park, was built on a brewer's land. The sale of beer at Phillies games seemed to turn things around dramatically at the stadium. A new electronic scoreboard was installed in July 1974. The parking lot was macadamized in 1977. Things were looking up for the Reading Phillies and the old ballpark.

One major item continued to linger over the heads of the Phillies and the city. Actually, it was what was not over their heads—a stadium roof. Even as construction workers topped off the topless stadium in 1951, the matter of a roof had vexed its promoters. In 1952, the Reading Indians circulated a petition asking citizens to urge the city to put a roof over the grandstand. At an estimated cost of $146,000 then, the city considered the matter one of low priority.

In 1953, one scheme suggested that the roof from a stadium that was being dismantled in Hartford, Connecticut, might be moved to Reading and rebuilt at Municipal Stadium. That idea went nowhere. The entire roof concept went nowhere until 1986, when the stadium and the Reading Phillies organization changed forever, and for the better.

THE PHILLIES ERA BEGINS. This is the team that ushered the era of the Reading Phillies into Baseballtown. The 1967 club included, from left to right, the following: (front row) Billy Wilson, pitcher; Joe Cherry, catcher; Charlie Shoemaker, second base; Dave Watkins, outfield; Bill Tomaselli, infield and outfield; Bob Chandanais, catcher; Frank Pollard, pitcher; and Brian Pfleger, bat boy; (middle row) Pete Cera, trainer; Morriss Steevens, pitcher; Leroy Reams, infield and outfield; Howie Bedell, outfield; Glen Clark, infield and outfield; Jim Campbell, first base; Jeff Harrell, pitcher; Paul Brown, pitcher; Frank Lucchesi, manager; and Bob Quinn, general manager; (back row) Jim Bronson, management trainee; Jim Perkins, outfield; John Penn, pitcher; Gary Schlieve, pitcher; Phil Krous, pitcher; Al Raffo, pitcher; Gene Rounsaville, pitcher; Charlie Green, third base; and Warren Halverson, shortstop. (Reading Phillies files.)

THE 1968 READING PHILLIES. In 1968, Ron Allen, Dick Allen's brother, led the Phillies in hits (117), home runs (25), doubles (25), and RBIs (97). One infielder, however, emerged from the team to go on to bigger things with both the Reading and Philadelphia teams, on the field and in the dugout. That is Larry Bowa, second from the left in the front row. (Reading Phillies files.)

READING'S POWER TEAMS. From the very beginning, Reading's regional power company was a strong supporter of baseball in town. Note on this 1968 Reading Phillies scorecard the mention of "Met Ed," or the Metropolitan Edison Company. When the opportunity for naming rights to the stadium came up, the electric company took advantage of it. In 1999, Reading Municipal Memorial Stadium was renamed GPU Stadium by General Public Utilities, which then owned what was formerly Metropolitan Edison. Later, when GPU became FirstEnergy, the stadium was given its new name, FirstEnergy Stadium.

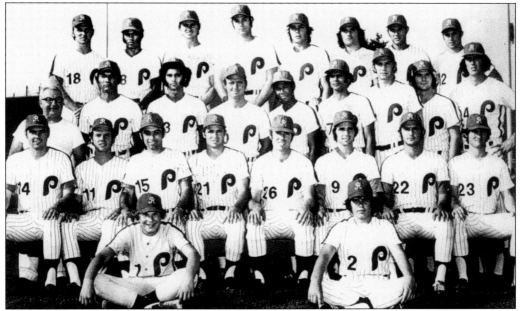

THE 1973 READING PHILLIES. Pictured, from left to right, are the following: (front row) Jim Ziegler, Rusty Klobas, Rich Giallella, Dane Iorg, Cal Emery (manager), Mark Crane, Erskine Thomason, and Bob Browning; (middle row) Pete Cera (trainer), Tony Gonzalez (coach), Blas Santana, Bob Terlicki, Fred Andrews, Nellie Garcia, Don Kreke, Chuck Kniffin, and Ron Diorio; (back row) Ken Fuller, Jim Lewis, Steve Cates, Larry Kiser, Jerry Martin, Jim Essian, Randy Boyd, and John Stearns. The bat boys in front are unidentified. (Reading Phillies files.)

"MICHAEL JACK." Mike Schmidt accepts his Hall of Fame poster from Charles M. Gallagher, managing editor of the *Reading Eagle*. Schmidt had a great year in Reading in 1971 and had an incredible career in the majors. He was the National League MVP three times, won 10 Gold Gloves, was a National League All-Star 12 times, and was the MVP of the 1980 World Series. He was elected to the National Baseball Hall of Fame in 1995. (*Reading Eagle* files.)

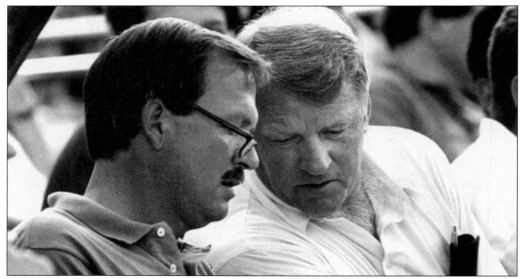

TENDING TO THE FARMHANDS. Reading's proximity to Philadelphia makes it easy for the parent team's front office executives to drop by the stadium and catch a Reading Phillies game. Here, Del Unser (left) chats with Phillies general manager Lee Thomas in the stadium stands in 1990. Unser set a major-league record by hitting three consecutive pinch-hit homers, was a hero in the 1980 World Series, and served as director of player personnel for the Philadelphia Phillies. In 1993, Thomas was named Major League Baseball Executive of the Year. (*Reading Eagle* files.)

LARRY BOWA MAKES THE HALL. Charles M. Gallagher hands the microphone to Larry Bowa after the shortstop for the 1967–1968 Reading Phillies was inducted into the Reading Baseball Hall of Fame. The man who became manager of the Philadelphia Phillies was a five-time National League All-Star. He also won two Gold Gloves. Other members inducted into the hall when Bowa entered in 1988 were Ruly Carpenter, who was the first president of the Reading Phillies (1967–1968) and later president of the Philadelphia Phillies (1969–1980), and Dick Wissel, who played for the Reading Phillies from 1970 to 1972 and in 1975. Wissel was an Eastern League All-Star in 1971.

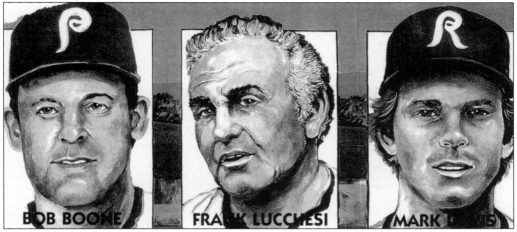

MORE STARS. The 1989 inductees into the Reading Baseball Hall of Fame are, from left to right, Bob Boone (Reading Phillies, 1971), Frank Lucchesi, and Mark Davis. Boone was a four-time All-Star in the majors and won seven Gold Gloves. Frank Lucchesi was the manager of the first Reading Phillies team in 1967, and a year later, his Phillies won the Eastern League championship. He also managed the Philadelphia Phillies from 1970 to 1972. Mark Davis was on the Reading Phillies' roster in 1980 and won the Eastern League Player of the Year award.

MARLON BYRD. After a near career-ending leg injury, Marlon Byrd battled back and was selected by the Phillies in the tenth round of the 1999 amateur draft. Byrd had a great year in Reading in 2001 and worked his way to the "big team" in Philadelphia briefly in 2001. At the time of the writing of this book, he was touted as the Philadelphia Phillies' center fielder. (Photograph by Steve Hendricks, Blind Squirrel Photography.)

HOWIE IN THE HALL. Popular Pennsylvania native and Pottstown resident Howie Bedell (center) was among those chosen for the Reading Baseball Hall of Fame in 1990. Bedell played for the Phillies from 1967 to 1969. In his first year here, he led the team in batting and RBIs. Also inducted into the hall that year were Andre Thornton (right), who played for the Reading Phillies in 1971 and went on to become a two-time American League All-Star, and Paul Owens (left), manager of the 1983 National League champion Philadelphia Phillies. Owens was voted into the Reading hall because of his work at the highest levels of the Phillies organization to bring the Phillies franchise to town.

THE CLASS OF 1991. Ray Starnes, who played for the Reading Phillies from 1970 to 1972 (and was an Eastern League All-Star in 1972), and Dallas Green were among the 1991 inductees into the Reading Baseball Hall of Fame. Green was a player-coach for the Reading Phillies in 1967 and was manager of the world champion Philadelphia Phillies in 1980. As Phillies farm director from 1972 to 1979, he became (and remains) a familiar face in the FirstEnergy Stadium box seats. (*Reading Eagle* files, photograph by Chad A. DeShazo.)

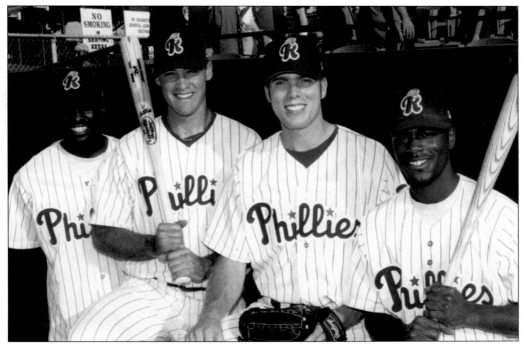

THE FAB FOUR OF 1999. These players are, from left to right, Reggie Taylor, Pat Burrell, Adam Eaton, and Jimmy Rollins. Taylor played in Reading in 1998 and 1999 and has since become an outfielder for the Cincinnati Reds. Adam Eaton wore the Reading "R" in 1999 and was last in the San Diego Padres organization. Burrell and Rollins, as any Phillies fan knows, have become solid performers for Philadelphia. (Photograph by David M. Schofield.)

HE'S THE MANN. David Mann, to be exact. You will see his picture on page 89, but this is from the night in 1999 that he joined the Reading Baseball Hall of Fame. He was in good company. Also in the Class of 1999 were Tommy Barrett, who hit a Reading franchise record .334 in 1987, led the Eastern League as a second baseman in fielding percentage, putouts, assists, and double plays, and also led the league in walks (95) and games played (136); Kevin Gross, a 1982 Reading Phil who went to the "Big Phils" from 1983 to 1988 and pitched a no-hitter on August 17, 1992, against San Francisco; Mark Helminiak, Reading Phillies general manager from 1978 to 1985 and 1981 Eastern League Executive of the Year; and the legendary "Clown Prince of Baseball," Max Patkin. (Photograph by David M. Schofield.)

MIKE SCHMIDT NIGHT. It was in a Corvette in 1971 that Mike Schmidt drove to Reading to play his first professional baseball game. And, it was in a Corvette on June 20, 1991, that Mike Schmidt was chauffeured on the night his No. 24 Reading Phillies jersey was retired by the club. (Photograph by the author.)

A ROSE FOR SCHMIDT. Although banned from baseball almost two years before, Pete Rose came to Reading on Mike Schmidt Night to offer some words of praise for his friend. Rose called Schmidt "the greatest player I've ever played with" as a surprised crowd looked on. (*Reading Eagle* files.)

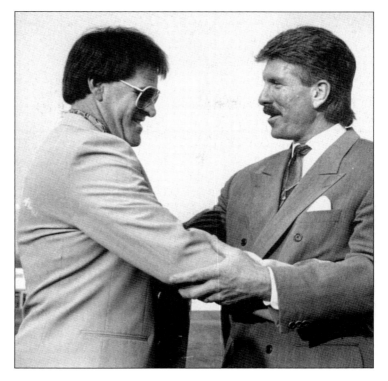

TRUE BASEBALL LEGENDS. Pete Rose (left) and Mike Schmidt exchange platitudes the night Schmidt's uniform number was retired by the Reading Phillies. (*Reading Eagle* files.)

THE BULL. Greg "the Bull" Luzinski was a fan favorite—especially when he boomed one of his 33 home runs over the walls of the stadium while playing for the Reading Phillies in 1970.

SETTING STRATEGY. John Quinn (seated), then general manager of the Philadelphia Phillies, discusses the Reading Phillies' 1972 lineup with, from left to right, Jim Bronson, Reading Phillies general manager; Earl Fetterman, secretary of the Reading Phillies Boosters Club; and Greg Luzinski, the Philadelphia Phillies' star rookie who played for Reading in 1970. (*Reading Eagle* files.)

MICKEY MORANDINI. Seen here as a Reading Phillie in 1989, Kittaning, Pennsylvania native Michael Robert Morandini was called up to the big club the following year and went on to an 11-year career with the Phillies, Cubs, and Blue Jays. (*Reading Eagle* files, photograph by Chad D. DeShazo.)

BRANDON DUCKWORTH. The big right-hander went 13-7 for the Reading Phillies in 2000 and was on the Philadelphia Phillies' staff in 2001 and 2002. He is another Reading graduate that the parent club has high hopes for. (Photograph by Steve Hendricks, Blind Squirrel Photography.)

MIKE WILLIAMS. The big right-hander's year at Reading in 1991 went well enough for him to be called up to Philadelphia in 1992. He spent five years with the Phillies and was most recently the Pittsburgh Pirates' closer. (*Reading Eagle* files.)

ROBIN ROBERTS. One of the most storied ballplayers ever to don a Reading Phillies uniform was Hall of Famer Robin Roberts. His major-league career (seven-time All-Star, two-time MLB Player of the Year, a 20-game winner in six consecutive seasons) was legendary. It was after his last year in the majors, 1966, that he came to Reading with hopes of making it back to the majors. He was 40 years old when he signed with the 1967 Reading Phillies, where he posted a 5-3 record (including two straight shutouts) and a 2.48 ERA. (Philadelphia Phillies.)

CARLOS SILVA. The Venezuelan righty was signed by Philadelphia as a free agent in 1996 and in 2001 posted a 15-8 record in Reading. It earned him a promotion directly to Philadelphia, where he went 5-0 in 2002. (Photograph by Steve Hendricks, Blind Squirrel Photography.)

BILL DANCY. Although his career managing record at Reading (1983–1984, 1988, 1994–1995) yielded a 350-347, .502 mark, Dancy's tenure (five seasons) and win total puts him ahead of any other Phillies manager in history. What's more, Dancy once played for the Reading Phillies (1974–1976, 1978). Dancy was named Minor League Manager of the Year by *Sporting News* and *Baseball America* in 1983 and was Manager of the Year in the Eastern League in 1995. His 1983 team (led by the likes of Juan Samuel and Darren Daulton) won a franchise record 96 games, and his 1995 squad won the Eastern League championship. (*Reading Eagle* files.)

AL LeBOEUF. Seen in his Reading Phillies playing days (1984 and 1988), LeBoeuf went on to manage the Reading Phillies in 1997 and 1998. In 1997, he piloted the team to a 74-68 record and was named Manager of the Year in the Eastern League by the league and the Eastern League Baseball Writers Association. (Photograph by David M. Schofield.)

DON McCORMACK. McCormack managed the Reading Phillies from 1990 to 1993. His four-year record in Reading was 250-305. (*Reading Eagle* files.)

MIKE HART. After a season (1980) with the Texas Rangers and several years in the minors, Mike Hart donned a Reading Phillies cap to become manager of the team in 1989. His team finished with a 68-71 record. (*Reading Eagle* files.)

GARY VARSHO. After eight seasons on four teams in the majors, Varsho ended his playing career in 1995. He managed in the Midwest League and came to the Reading Phillies as manager from 1999 to 2001. He led the team to one league co-championship and garnered a Manager of the Year award while compiling a 221-185 record. (Photograph by David M. Schofield.)

GREG LEGG. Seen here as a player (1988) for the Reading Phillies, Greg "Legger" Legg played his first season as a professional in 1983 at Reading, and went on to hit .306 in 90 games at shortstop for the Reading Phillies. He made his major-league debut in 1986 and hit .450 (9-20) in 11 games for the Phillies. He played the last six years of his career for Scranton–Wilkes-Barre and ranks in the top five all-time in several Red Barons categories, good enough to have his number 14 retired by the Red Barons. Legg was named the 20th manager in Reading Phillies history on October 16, 2001. (*Reading Eagle* files.)

BILL ROBINSON. After a major-league career with the Braves, Yankees, Phillies, and Pirates, Bill Robinson came to Reading in 1996 to manage the Phillies for one season. (Photograph by David M. Schofield.)

SCOTT ROLEN. In 1995 and 1996, Scott Rolen played for the Reading Phillies. In 1967, Scott Rolen was the National League Rookie of the Year. Does that say anything about the quality of baseball played at FirstEnergy Stadium? Of course, Rolen has left the Phillies organization, but it was in Reading where he fine-tuned his skills. (Photograph by David M. Schofield.)

WAYNE GOMES. Wayne Gomes was a Phillies (and later Giants) reliever was also a member of the Reading club in 1995 and 1996. (Photograph by David M. Schofield.)

111

RANDY WOLF. Before the "Wolf Pack" howled for the popular pitcher in the confines of Veterans Stadium in Philadelphia, Randy Wolf played for the Reading Phillies in 1998. He made a return to Reading for some rehabilitation in 2001. He went 10-11 with the Philadelphia Phillies in 2001 and was 10-9 in 2002. The Phillies proved that they were committed to Wolf as a major player in their future when, on December 13, 2002, they signed him to a four-year, $22.5 million contract. (Photograph by David M. Schofield.)

JOHNNY ESTRADA. After a good year with the Reading Phillies in 2000, Johnny Estrada, a popular catcher, was called up to Philadelphia, where he spent two seasons before being traded to the Atlanta Braves. In his year in Reading, Estrada hit .295 and had 12 home runs. In return for Estrada, the Phillies received Kevin Millwood, who went 18-8 for the Braves in 2002 and was immediately installed in the Phillies' starting rotation for 2003. (Reading Phillies files.)

JOHN KRUK. Whether it was for San Diego, Chicago, Philadelphia, Reading, or *Late Night with David Letterman*, the colorful John Kruk gave 100 percent to the game and to the fans. "Krukker" was hero of the 1993 Philadelphia Phillies and came to Reading for a brief rehabilitation stint in 1994. He returned to Reading a few years later as a hitting coach. (Reading Phillies files.)

PETE ROSE JR. Son of "Charlie Hustle," Pete Rose Jr. never quite made the major-league grade. He spent more than a dozen years in the minors, including parts of the 2000 and 2001 seasons with the Reading Phillies. (Photograph by David M. Schofield.)

BRETT MYERS. Myers tuned up for his call-up to the majors with a season in Reading in 2001. The Phillies' first-draft choice in 1999, he was taken right out of high school and sent into the system as the hottest of a group of hot prospects. He made his major-league debut with the Phillies in 2002. (Reading Phillies files.)

PART OF THE JOB. Few players came to the Reading Phillies with higher hopes and expectations as Pat Burrell. Shown here being interviewed by a local television station, Burrell did not disappoint the Reading fans. In his 1999 season, he led the team in batting average (.333), home runs (28), RBIs (90), doubles (28), runs scored (84), total bases (219), bases on balls (79), and strikeouts (103). (Photograph by David M. Schofield.)

PAT BURRELL. Seasoned Reading Phillies fans often compared Pat Burrell to the Bull (Greg Luzinski) in their seasons spent at Reading. The comparison was valid. In 1970, Luzinski hit .324, had 33 homers, and batted in 120 runs. He also played 24 more games in 1970 than Burrell did in 1999. Burrell and the Bull are the only players in Reading baseball history to smack 25 or more homers and bat over .320. (Photograph by David M. Schofield.)

TRAVIS CHAPMAN. Chapman, the Reading Phillies 2002 MVP, was selected by the Cleveland Indians in the first round of the Rule 5 draft in December 2002 and was then promptly traded to Detroit. Chapman spent seven games with Reading in 2001 and played an instrumental role in the Phillies playoff success that year. Last season, he became the team's everyday third baseman and batted a team-high .301. He led the club in home runs (15), hits (144), and doubles (35). Chapman started at the hot corner for the National League in the Double-A All-Star Game in July and was named to the Eastern League postseason All-Star squad and Eastern League Baseball Writers Association All-Star team. (Photograph by Ralph L. Trout.)

"BUZZ" HANNAHAN. He cringed if you called him Leonard Bisanz Hannahan and was more commonly known as "Buzz" Hannahan. The fleet-footed, hard-playing second baseman loved his years with the Reading Phillies, and fans loved when he came to the plate—or went into a head-first slide, as witnessed here. (Photograph by Ralph L. Trout.)

NATE ESPY. Another fan favorite, the power-hitting Nate Espy is milliseconds away from catching a ball thrown to his first-base position. In 2002, Espy hit .267 for the Reading Phillies. (Photograph by Ralph L. Trout.)

RUSS JACOBSON. The Reading Phillies catcher, Russ Jacobson, is caught in the moment as he whips a ball toward second base in an attempt to pick off a runner. Jacobson finished the 2002 season in Reading with an average of .282. (Photograph by Ralph L. Trout.)

A PREGAME PAUSE. As in every other baseball game ever played in Reading, players and fans take a moment to honor America and its flag as the national anthem is sung or played over the public-address system. Here, Phillies star Pat Burrell (40) stands tall with two of his teammates and a group of youngsters chosen to accompany the players in the infield for the pregame ceremonies. (Photograph by David M. Schofield.)

Eight

FUN IN BASEBALLTOWN

In December 1986, Craig Stein came from the Philadelphia suburbs to Reading and bought himself a baseball club. That investment marked the beginning of one of the most exciting and successful periods in Reading baseball history. From the very start, Stein and general manager Chuck Domino got it right.

That start actually had its genesis in Florida. After Stein purchased the team from Joe Buzas, the two toured several spring-training facilities in the Sunshine State and ideas were infused in the new owner's imagination. Further explorations in other minor-league parks helped mold Craig Stein's vision for the Reading Phillies and their stadium.

Gaining confidence and cooperation of city officials, Stein and Domino worked swiftly to redefine the Phillies. Energetic, innovative, and talented management and marketing teams were assembled inside, and sweeping changes came outside. No part of Municipal Stadium escaped those changes. New players' clubhouses, new umpires' changing rooms, thousands of new and more comfortable seats, and a spectacular video-enhanced scoreboard were among the improvements. And, oh yes, a roof was finally installed over a broad portion of the grandstand. Concession stands, offices, the press box, and the trainer's facilities were also expanded.

The playing field was given a complete overhaul, new seating and deck concession areas were built beyond the left-field fence, and a picnic area was built along the third-base line. An outdoor food court, games area, and then a pool-picnic area over the right-field fence continued the upgrades and expansions.

Between-inning activities, special promotional nights (and mornings) added to the family atmosphere of what made baseball fans across the United States stand up and take notice. The Reading Phillies and what was to become FirstEnergy Stadium gained national recognition and were embraced with unbridled enthusiasm.

Pittsburgh native and general manager Chuck Domino came right out of the gate with prestigious honors. In 1988 and again in 1989, he was the Eastern League Executive of the Year. In 1989, the *Sporting News* also named him the Class AA ball Executive of the Year. In 1991, the Phillies received the top honors in all of Class AA baseball, the Bob Freitas Award as the best Class AA operation, and the Eastern League Executive of the Year award came back to Reading, to Craig Stein. Dan "Dirt" Douglas, stadium groundskeeper, won the first of his several awards in 1993, when he was named Eastern League Groundskeeper of the Year, and the marketing and promotional teams garnered even more honors throughout the 1990s and into the 21st century.

Baseball fans kept the proverbial turnstiles spinning at the stadium. In 1987, the season attendance was 87,925 with an average crowd of 1,465 per game. In 2002, season attendance topped 486,000, with a per-game average attendance of just over 7,000. On the field, nearly all of the Phillies' hot prospects took their turn in Reading before making it to "the Show." Between innings, Reading fans stuck around for other kinds of shows, as you will see in the following photographs.

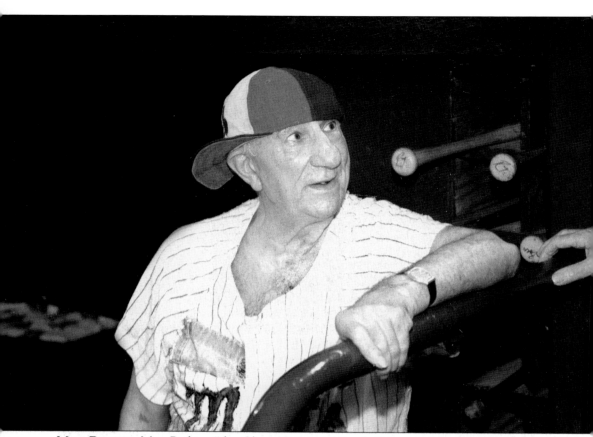

MAX PATKIN. Max Patkin, "the Clown Prince of Baseball," was a legendary baseball figure who performed in Reading more than in any other city during his career. A native of West Philadelphia, Patkin played himself in the movie *Bull Durham*. The six-foot three-inch Patkin was a star athlete at West Philly High School and was also a skilled dancer. He spent a few months in the Chicago White Sox minor-league organization in 1941. Patkin officially retired at Reading Municipal Memorial Stadium before a sellout crowd on August 19, 1995. He was inducted into the Reading Baseball Hall of Fame in September 1999 and died that October 30. (Photograph by David M. Schofield.)

SCREWBALL. The original mascot of the Reading Phillies, the chap who makes rare appearances now as Pappy Screwball, has gone into semiretirement, and the mascot lineup at Reading Phillies games now includes a hound (Blooper), a duck (Quack), a beaver (Bucky), a turtle (Change-Up), and a second-generation Screwball. (Photograph by author.)

THE CHICKEN. Making its debut with a radio station in San Diego, California, the Chicken has become a popular between-innings attraction at major- and minor-league games across the country. He has made several stops at Reading, including this episode when he got some Reading Phillies players (and front-office types) into the musical mood. (Reading Phillies files.)

DOWN ON THE FARM. They call the minor leagues the farm teams of the majors, and Chris Calvert (Reading Phillies, 1988–1990) got a tug or two in during a cow-milking contest at the stadium. (Reading Phillies files.)

GOBBLE, GOBBLE. The turkey is supposed to gobble, and the human is supposed to eat chicken. This 1989 photograph shows the Chicken giving a young boy a tentative thrill. The boy, incidentally, is Joseph D. Domino, the five-month-old son of Chuck Domino, Reading Phillies general manager. (*Reading Eagle* files.)

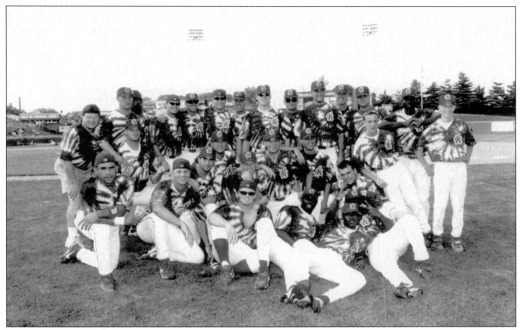

LIKE WOW, MAN. Looking cool in their tie-dyed jerseys, the 1999 Reading Phillies freak out on field for a team photograph during Tie-Dye Night at the ballpark. Check out the dude up front flashing everyone a peace sign. (Photograph by David M. Schofield.)

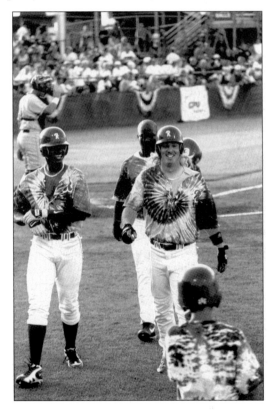

COMIN' HOME, DUDE. Steve Carver is all smiles as he heads to the dugout after smashing a home run on Tie-Dye Night in 1999. What a long, strange round-tripper it was! In 1998, Carver hit 21 home runs and batted .260 for the Reading Phillies. (Photograph by David M. Schofield.)

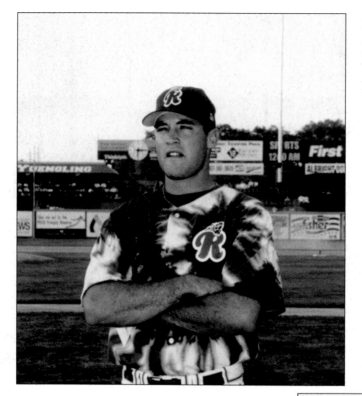

LOOKING COOL. Pat Burrell has a far-out look on his face as he digs the action during Tie-Dye Night at the Phillies' pad in 1999. (Photograph by David M. Schofield.)

THE INCREDIBLE TWO-HEADED MASCOT? No, this is just a shot of Reading Phillies mascot Screwball (in the shades) looking over the Phillie Phanatic's shoulders. The Phanatic got into the action on Tie-Dye Night, too. (Photograph by David M. Schofield.)

MORE MASCOTS. You want mascots? The Reading Phillies have mascots—at last count, five. Here, Change-Up and Bucky hold the slingshot while Screwball gets ready to fling a prize into the grandstand during between-inning fun at FirstEnergy Stadium. (Photograph by David M. Schofield.)

SQUIRTING THE SQUIRTS. Reading Phillies mascot Quack (the yellow fellow to the left) squirts a pool full of kids as he makes an appearance in the Reading Eagle Pool Pavilion just over the right-field fence at FirstEnergy Stadium. (Reading Phillies files.)

THE DRAG IN DRAG. Reading Phillies fans never know exactly what to expect in the way of promotions and between-inning antics. Sometimes, Reading Phillies employees are equally surprised. For example, in the middle of the fifth inning, Dan "Dirt" Douglas and his grounds crew do "the drag" and groom the infield. One night, Douglas was surprised as some Phillies' front-office types (names are being withheld to protect their dignity) did "the drag" in drag. (Photograph by David M. Schofield.)

NOW IT'S OVER. One of the odd customs at Reading Phillies games when Marco Cipolla was interning with the organization was the ascent of Marco the Viking in his Viking warship at the end of the game. When Marco sang—symbolizing "the fat lady"—the game was officially over. (Photograph by David M. Schofield.)

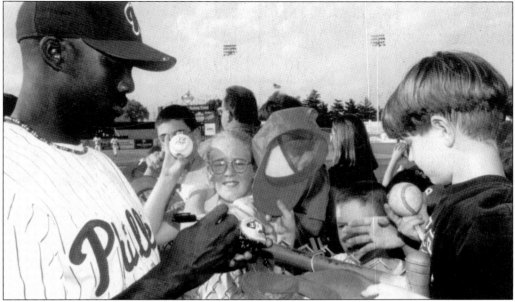

WHAT IT'S ALL ABOUT. A member of the Reading Phillies from 1996 to 2001, and one of the team's most community-minded players, Aaron Royster stayed with minor-league ball simply for the love of the game. Here, the popular outfielder who once drove in seven runs in a single game (one off the mark held by Steve Carver) works the young crowd. (Photograph by Ralph L. Trout.)

TOOLS OF THE TRADE. A certain magic fills the air in and around Reading's storied baseball stadium from April to September each year as the Reading Phillies bring top-notch baseball to town and the business and civic communities combine with Phillies' management to provide the fun and continue to validate Reading's claim as America's Baseballtown. (Photograph by David M. Schofield.)

LYRICS TO BASEBALLTOWN

In March 2002, the Reading Phillies announced that it had trademarked the name "Baseballtown, Reading, Pennsylvania" as a marketing image for the Phillies and for Baseballtown Charities, a nonprofit organization established to promote youth baseball in Reading and Berks County. Immediately after the ceremony that introduced the concept to the public, the author of this book wrote the words and music to what became one of the anthems of "Baseballtown." The song was debuted on the author's morning radio show on WEEU in Reading.

There's a Game Tonight in Baseballtown

From the crack of the bat to the sizzle of the hot dogs
The sugar on the funnel cakes, the foam on the brew
From the first "play ball" to the seventh inning stretch—
To Baseballtown we welcome you!

From Kurowski, Maris, Schmidt and Furillo,
To Bowa, Rolen, Burrell, and Byrd
They have played the game that we all love—
Here in Baseballtown, now, haven't you heard

On a summer's eve they're ballpark bound
The citizens of Baseballtown

On the sandlots, schoolyards, in college, legion, high school
T-ball, Little League, and softball, too
They pitch, they catch, they hit, they run—
And maybe make a big league dream come true.

It's American as flag and family,
It's as Reading as a shoo-fly pie.
Under lights or 'neath a sky of blue—
Baseball is a part of you.

There's a game tonight, so come on down
You citizens of Baseballtown
Baseballtown, Baseballtown
There's a game tonight in Baseballtown.